LIFE'S A DOG BONE
CHEW IT ALL DAY LONG!

LIFE'S A DOG BONE
CHEW IT ALL DAY LONG!

Pawsome
Quotes
for
Dog
Lovers

JEFF ALLEN

Cover photos: Kristen Kidd Photography
Book design by Christy Collins, Constellation Book Services
Quotes by Jeff Allen unless noted or universally recognized

ISBN (paperback): 978-1-7351810-2-8

Printed in the United States of America

Dedication

This is a tribute to the dogs of Monkey's House a Dog Hospice & Sanctuary. Through a multitude of challenges, they found peace and love in their final chapter. Although most of the dogs in this book have taken their final journey, they will forever live in our hearts.

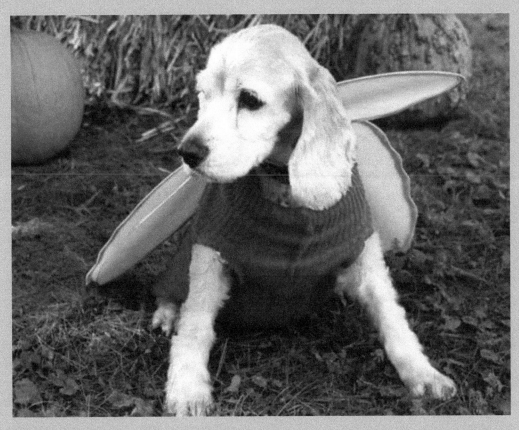

Molly

Introduction

Dog lovers cherish the companionship, devotion, and most importantly the love our furry friends bring into our lives. Our dogs are as much part of our families as a child, parent, brother or sister. The bonds we form with them is surreal, they seem to know what we need and when we need it. *Life's a Dog Bone, Chew it All Day Long* celebrates the lives of dogs through beautiful pictures aligned with a quote to match each dog's personality.

All the dogs in this book have one thing in common, they found themselves separated from their families when they needed them most. Senior dogs with major medical ailments, found themselves in the shelter system, close to being one of the million plus dogs and cats euthanized each year in the United States.

Thankfully, these dogs found their way to Monkey's House a Dog Hospice & Sanctuary. You'll find yourself falling in love with the happy, contented dogs featured in the pages of this book, and you'll quickly see that a dog hospice is not a sad place to be. Instead, it is an oasis of compassion, kindness, meaning, and love.

In my previous book *Where Dogs Go To Live,* I dive into the mission of Monkey's House. From the day-to-day operations, the unique approach we take to wellness, and finally, what it's really like to live with 25 hospice dogs on our little farm in New Jersey. Through the dog's stories I strive to bring the reader into our home, feel the dog's aura, and live our mission. I want the reader to imagine they are sitting in our family room surrounded by our pack of pups, with Hannah Bear on their lap.

Although that book (also in ebook) contains many photos, it is a black and white paperback book. With the inspiration of seeing the love and glory of our dogs in full color photos, I published *Life's a Dog Bone, Chew it All Day Long* containing over 70 cherished photos. A keepsake, celebrating the lives of dogs once forgotten.

As you scroll through the pages, you'll experience dogs living and loving life through beautiful pictures and meaningful quotes. Your heart will swell seeing the warmth of togetherness as dogs form beautiful friendships. You'll smile witnessing the happiness they experience and funny moments they create. Be inspired by dogs with disabilities, learning to live a new normal. Finally, with the wisdom these dogs teach us, you'll see that love really does conquer all.

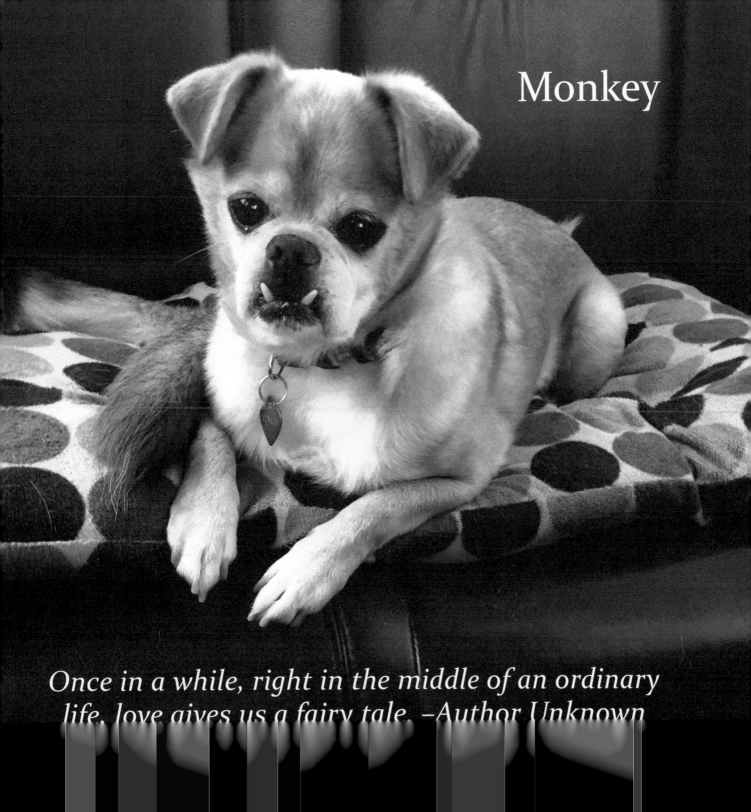

Monkey

Once in a while, right in the middle of an ordinary life, love gives us a fairy tale. –Author Unknown

Chase

*There's
no
place
like
home.*

9

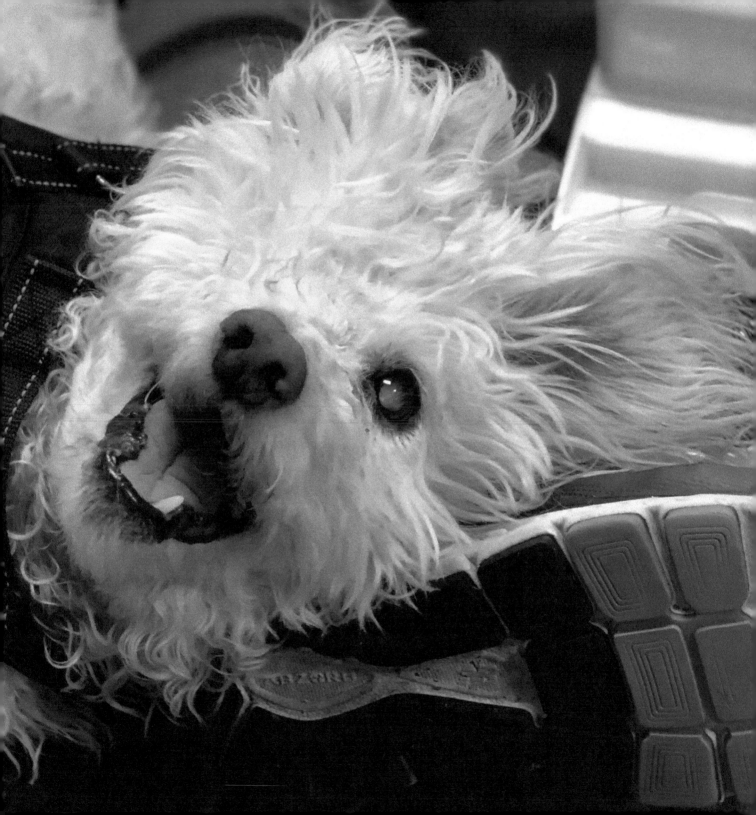

Smiley

*I've never met
a grumpy person
playing with
a dog.*

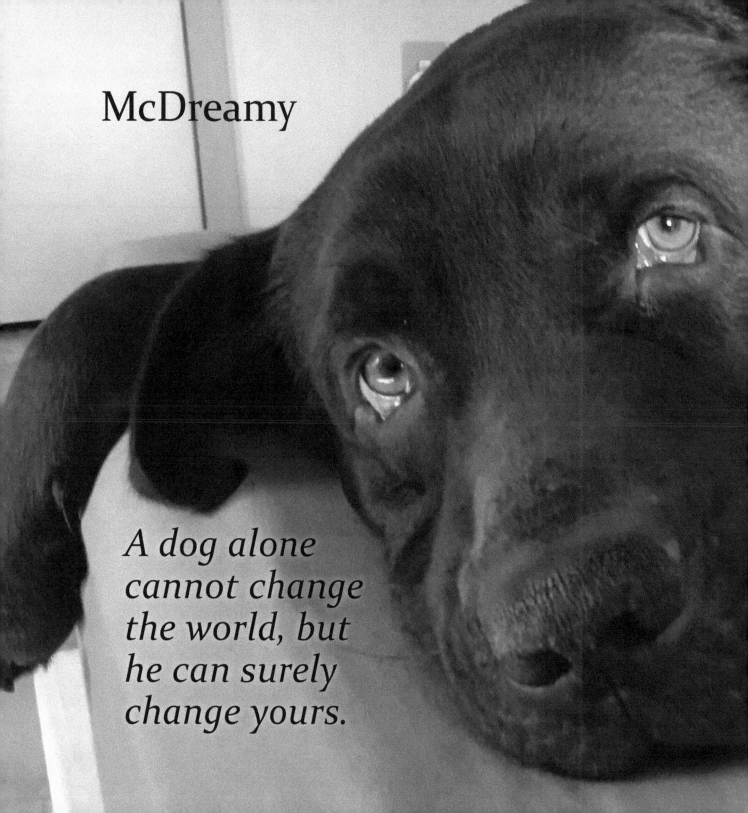

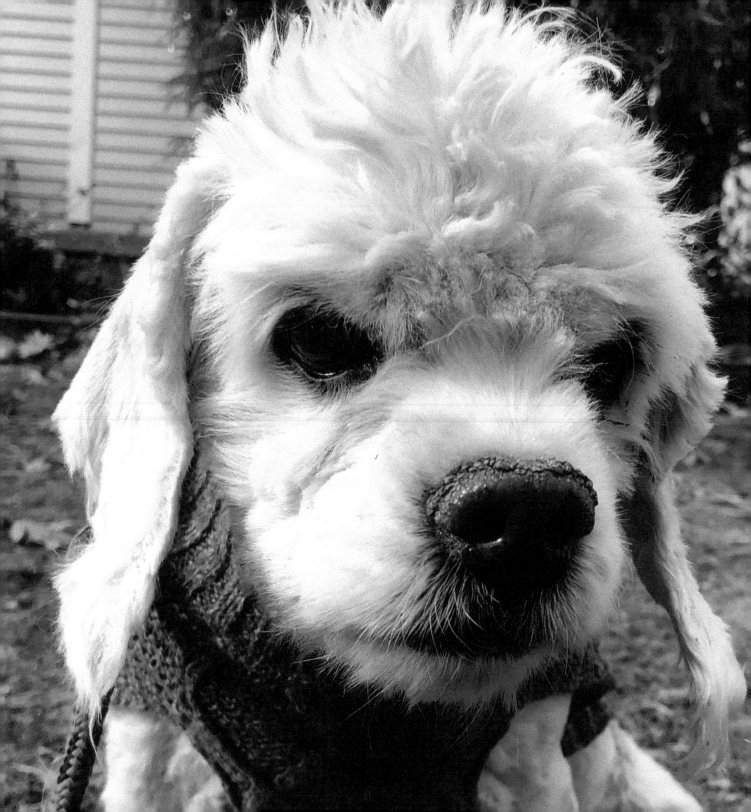

Madge

Even on a bad hair day,
your dog thinks
you're beautiful.

Isn't that what really matters?

Tequilla and Michele

*Special moments
can be as simple
as the warmth
of togetherness.*

 16

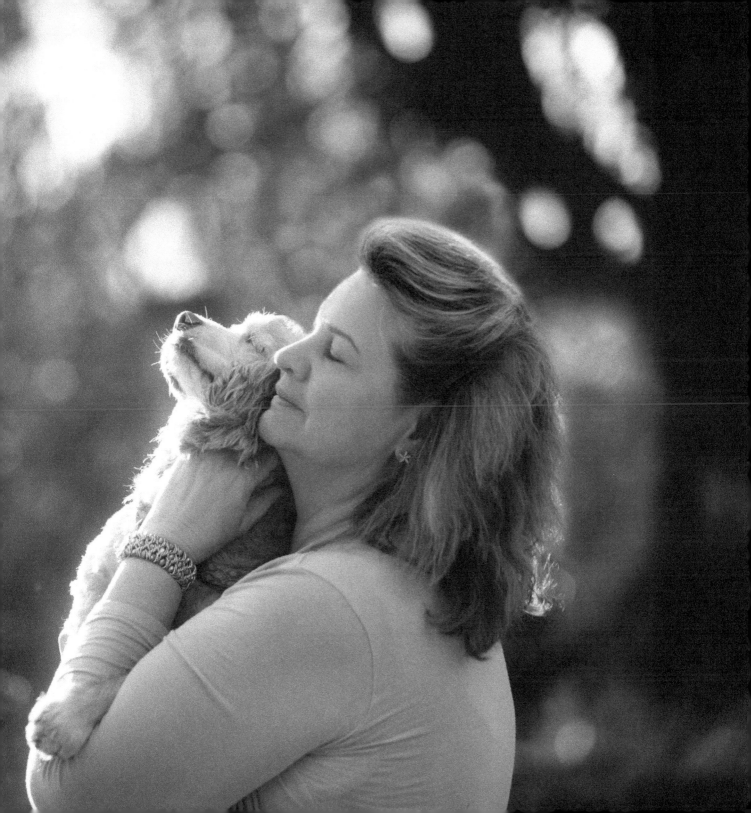

Harley

*Tis better to have loved and lost
than never to have loved at all.*

–Alfred Lord Tennyson

 18

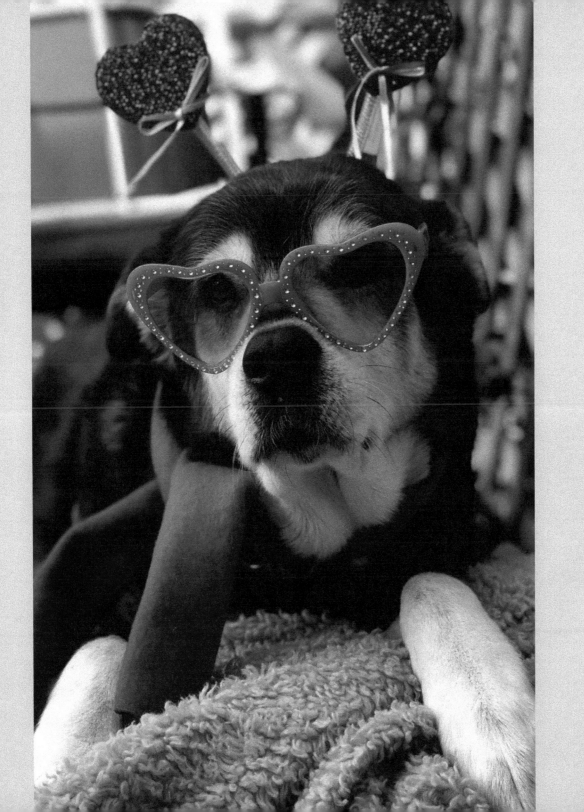

Chase

A hug a day is just what
the doctor ordered;
the wet nose in
your ear is optional.

Leo

*Realize you don't
have to know
everything they're
thinking or pretend
you do. Just enjoy
your time with them.*

Grandpaw

*Telling a cat that he's not a dog is a
lot like telling your wife she's wrong.
Agree with her, then go play
fetch with the cat.*

Joey

*Don't let the scents
of others misguide you;
stay on your own path.*

 26

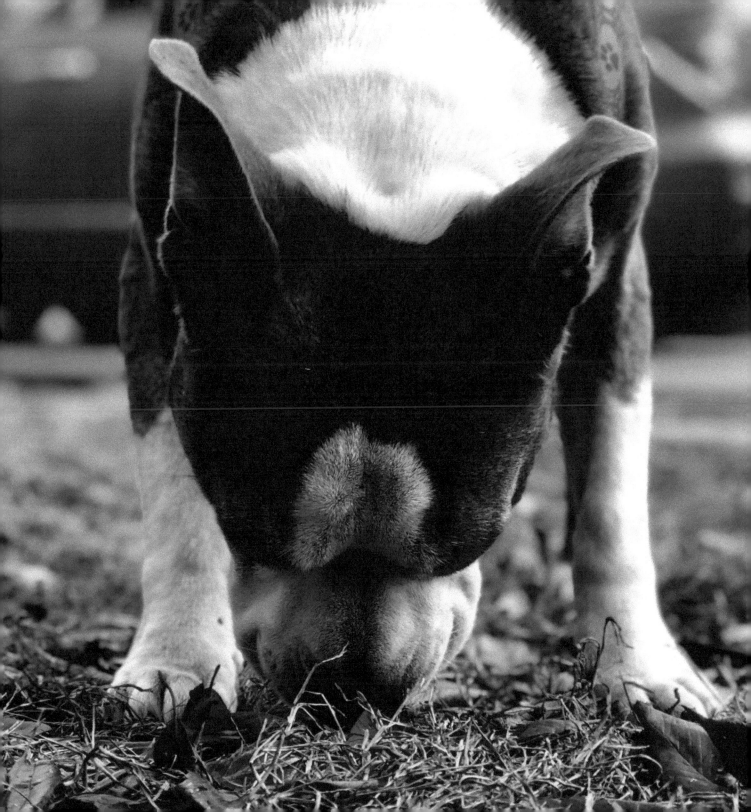

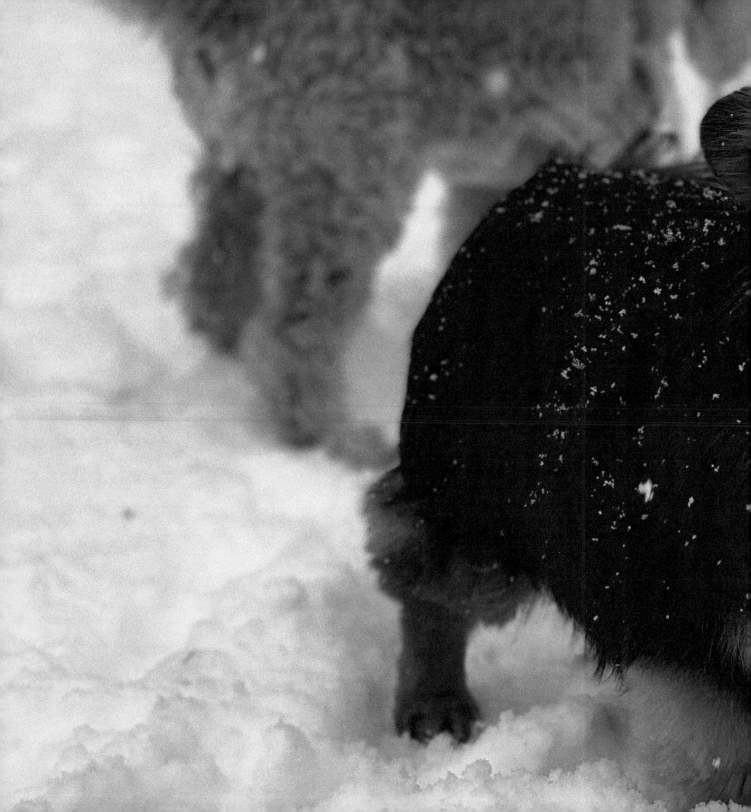

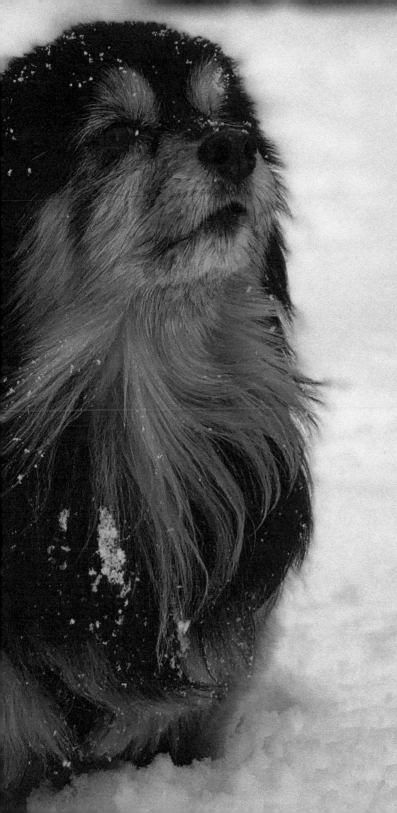

Hannah Bear

*Age is only
a number.
Let loose of your
inhibitions
and catch that
snowflake on
your nose.*

Buck

*Happiness is snuggling
under a blanket when it's
cold outside and still being
able to see the one you adore.*

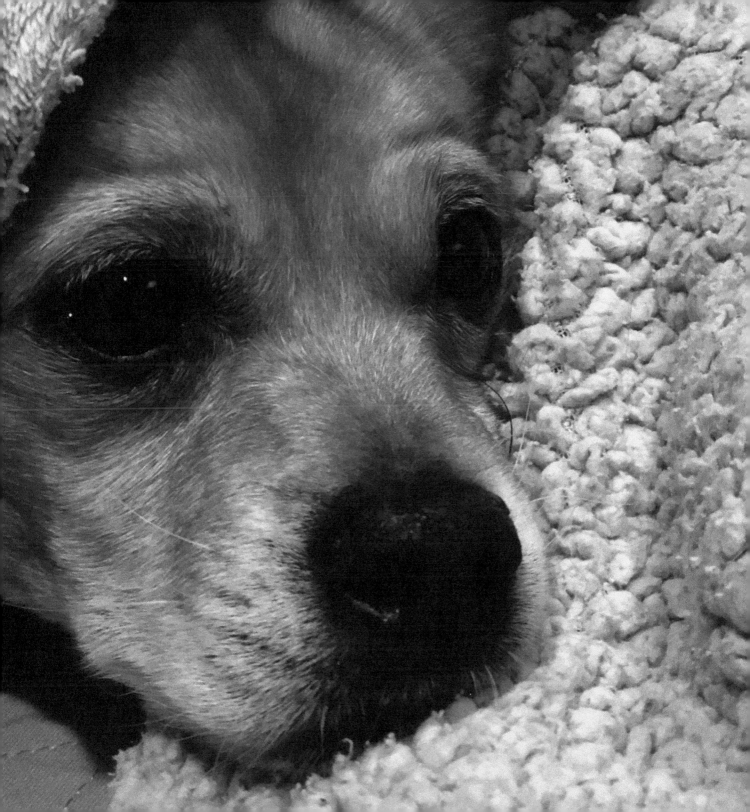

Jax

*The more I learn about people,
the more I like my dog.*

–*Mark Twain*

Rocky

*A dog will surely
turn a frown
upside down.*

34

Dozer

*Life isn't about giving
up under adversity.
It's about embracing
a new normal, living
life to the fullest of
your ability.*

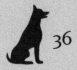
36

Eve

I don't go crazy, I am crazy.
I just go normal from
time to time.
–Author Unknown

Penny

*Sometimes words can
over complicate things when
all you need is a gentle kiss.*

 40

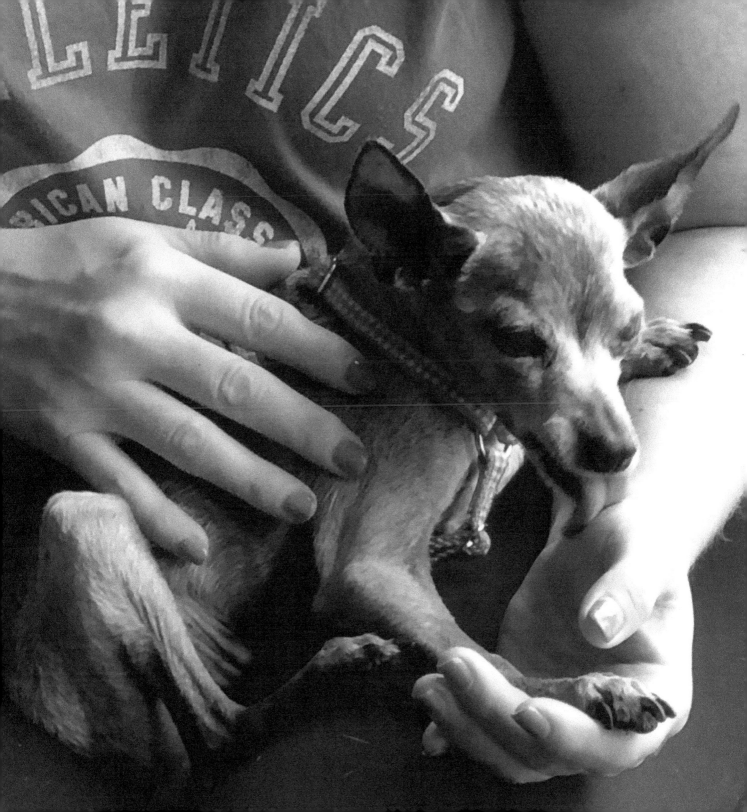

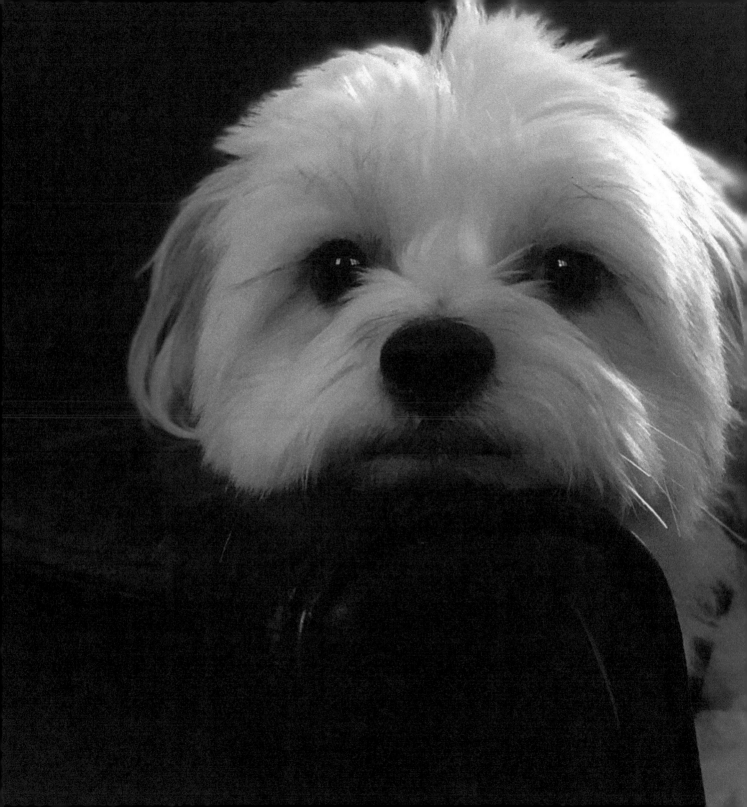

King

If there are no dogs in heaven, then when I die I want to go where they went.

–Will Rodgers

Penelope and Kaiden

*Every boy should have a dog
and a mother that encourages
him to have one.*

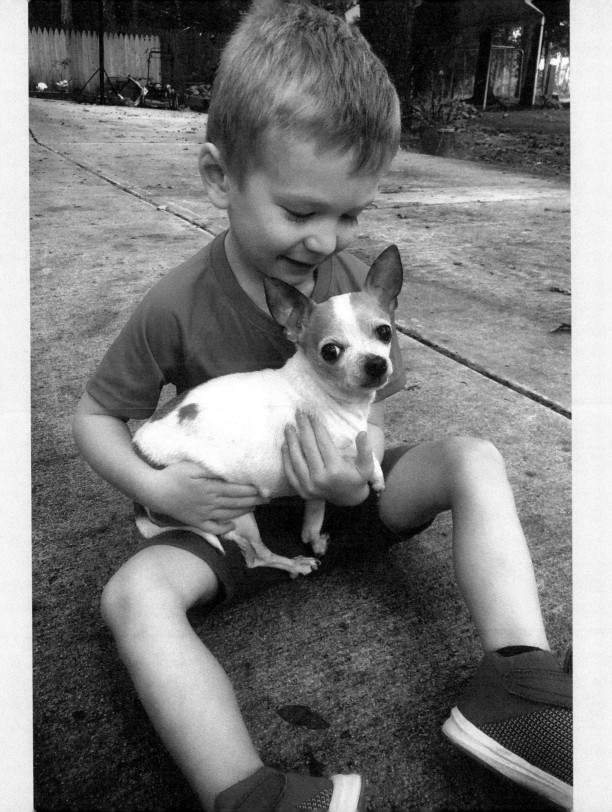

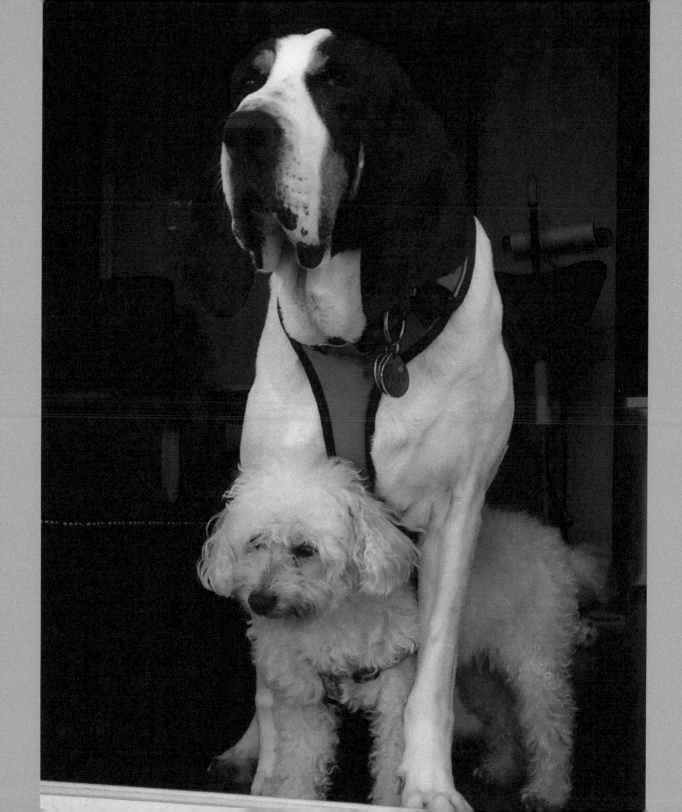

Bullwinkle and FiFi

I can't promise to solve all your problems but I can promise you won't have to face them alone.

47

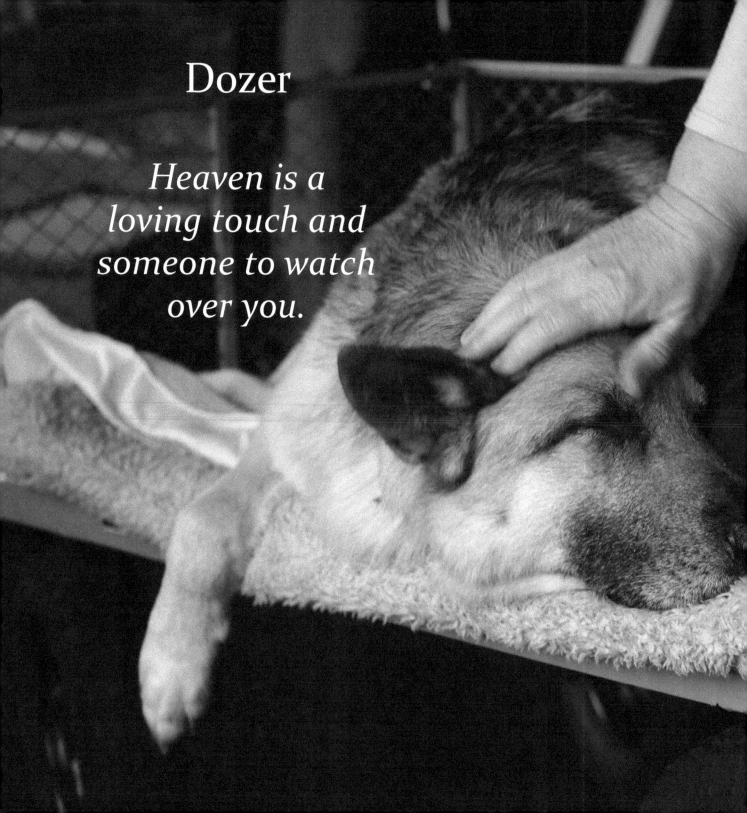

Dozer

Heaven is a loving touch and someone to watch over you.

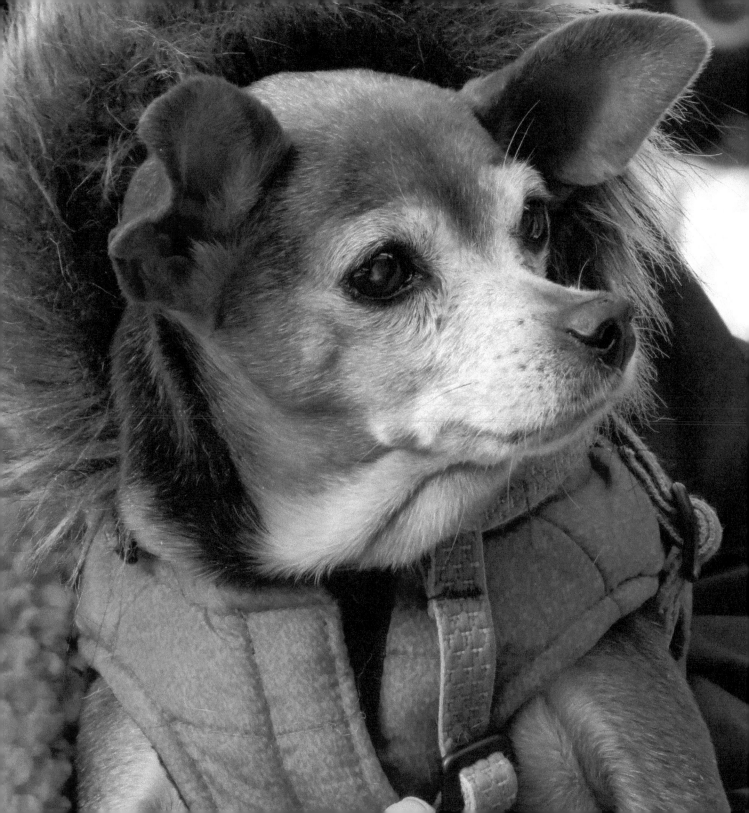

Maisey

The warmest of winter coats
won't warm your soul like
that of a dog.

51

CoCo

*Let sleeping dogs lie
or you'll just have to
walk them again.*

 52

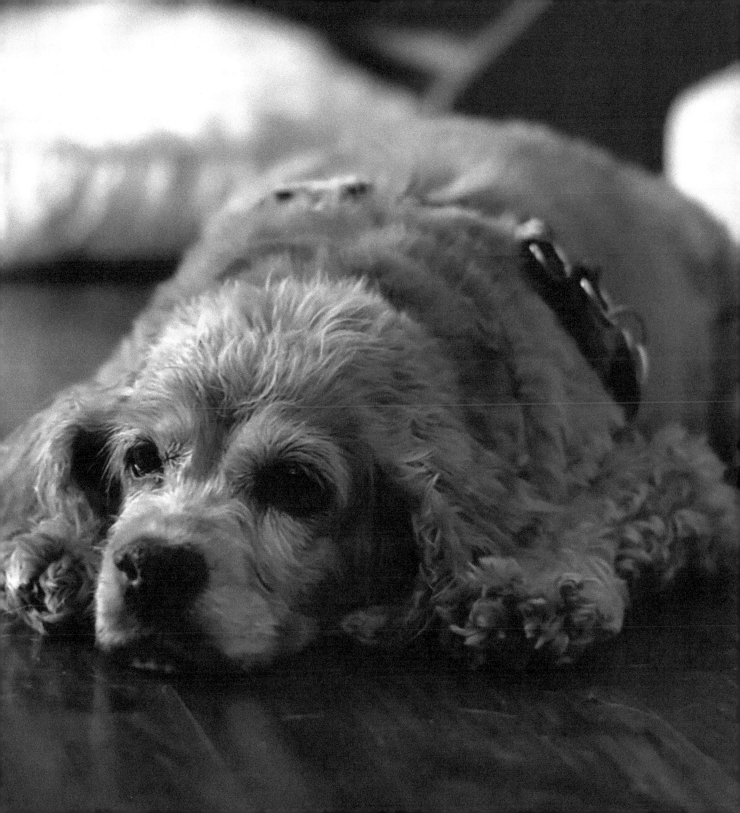

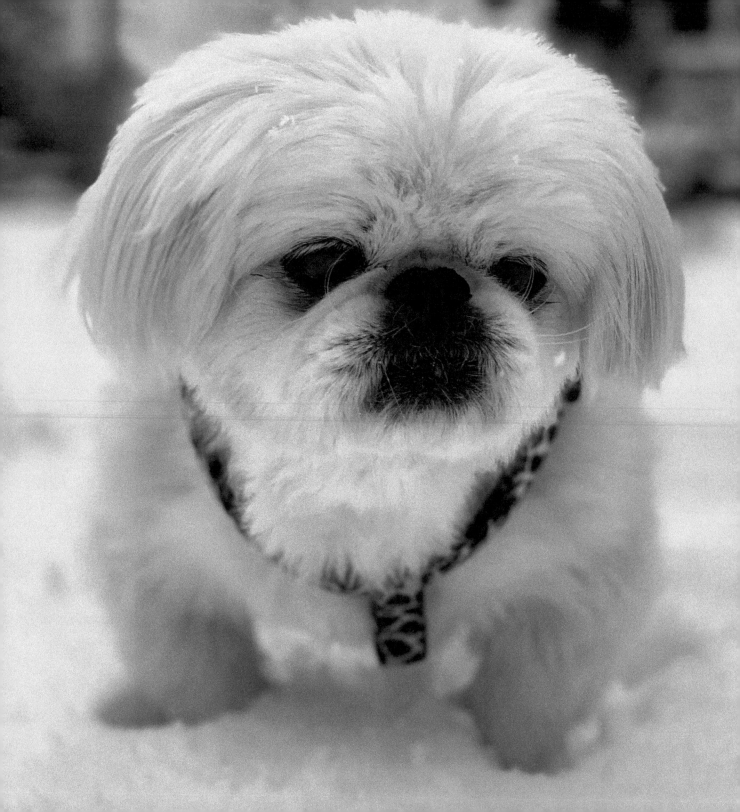

Cotton

There is no firmer a friendship than those formed between people who love the same dog.

Tequilla and Bunkey

In deep despair we are not looking for advice, solutions, or cures; rather someone to share our pain and touch our hearts. A friend who can be silent with us in the moment, just be there in our time of need.

J.J.

*I am always wondering
who the Alpha really is.*

 58

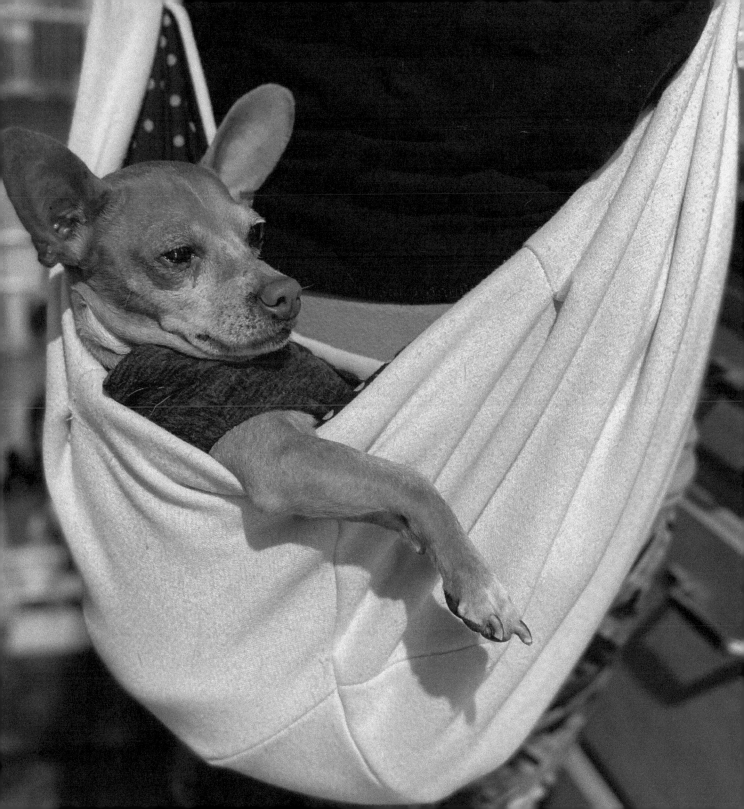

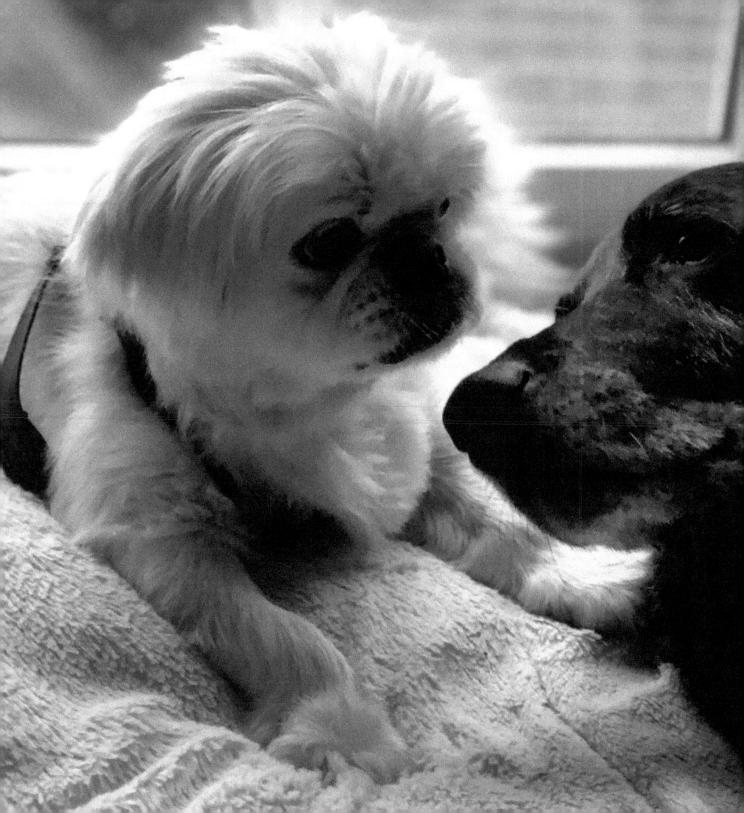

Cotton and Cole

*Whenever I see dogs
softly talking to one
another I do believe
they are up to
no good.*

61

Sora

Don't walk in front of me...
I may not follow.
Don't walk behind me...
I may not lead.
Walk beside me...
just be my friend.

–Author Unknown

 62

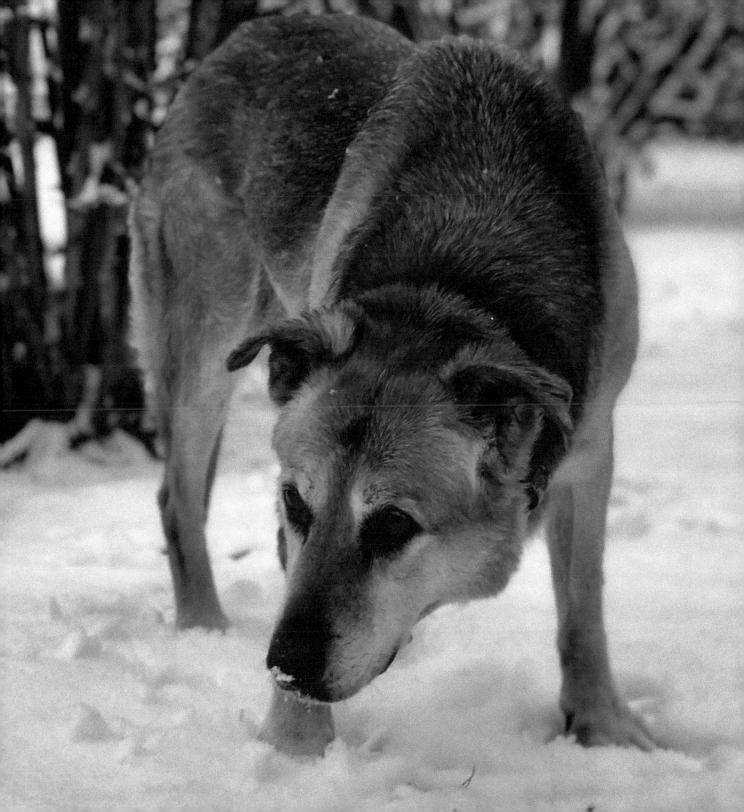

Tank and LuLu

*Great friends are always
by your side ready to
scratch your itch.*

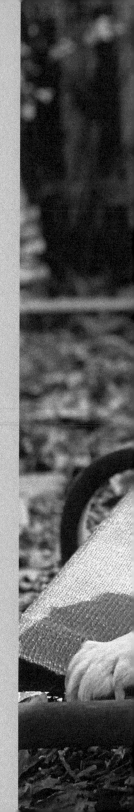

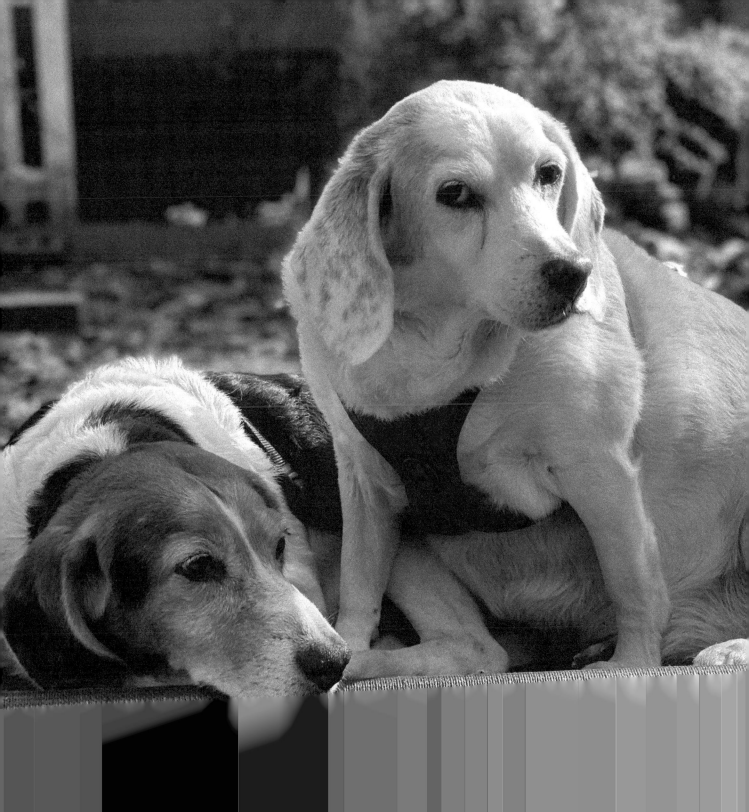

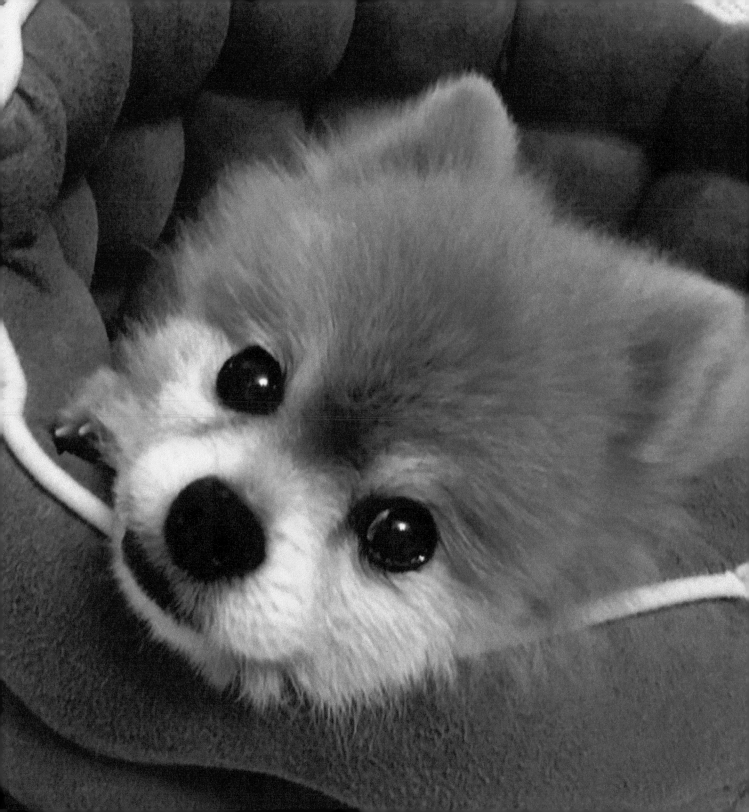

Pumpkin

The love seen in a dog's eyes
have the ability to hypnotize.

LA and Mattie

There is nothing like a friend
to lean on when you're not strong.
Someone to help you carry on.

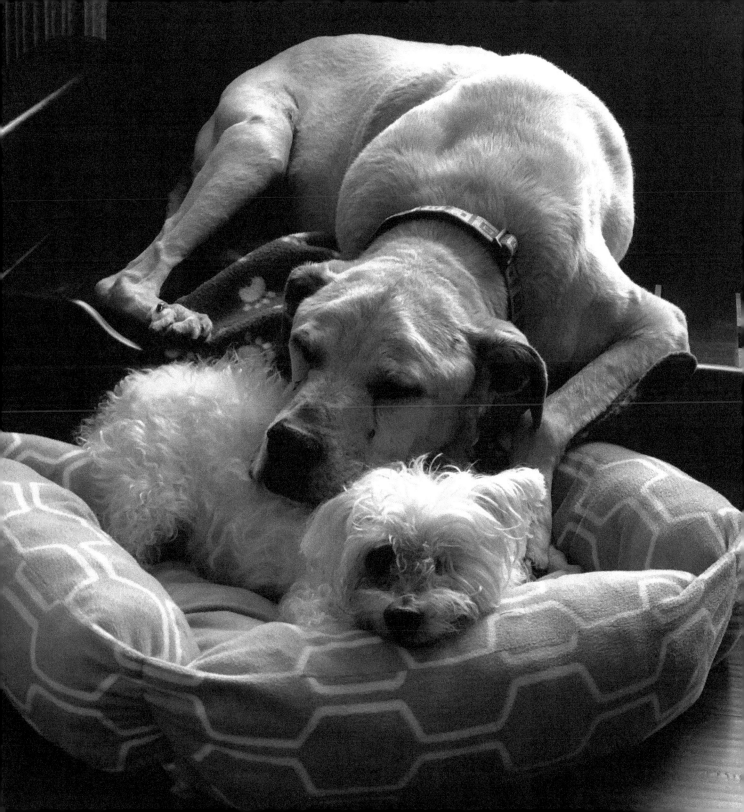

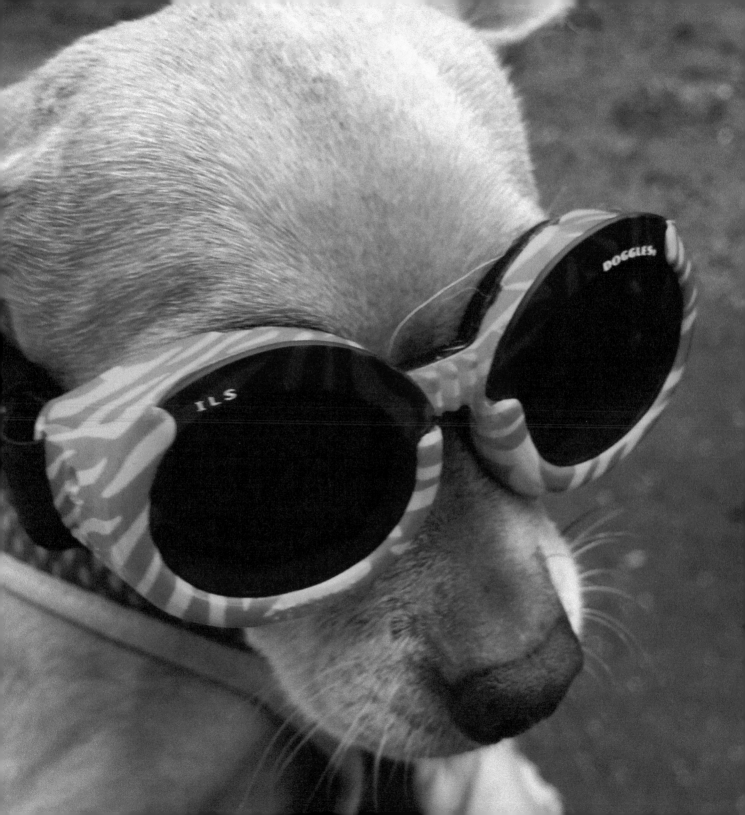

Daisy Mae

If ya got it, flaunt it!

Bea

Spending time in nature with your dog won't solve all your problems but it will let you know which ones are actually important.

 72

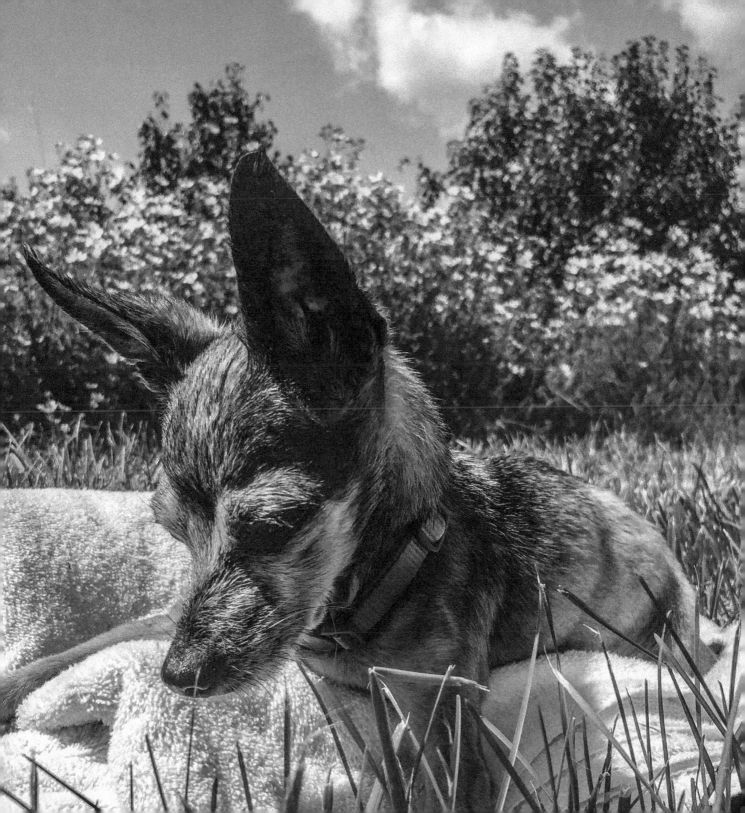

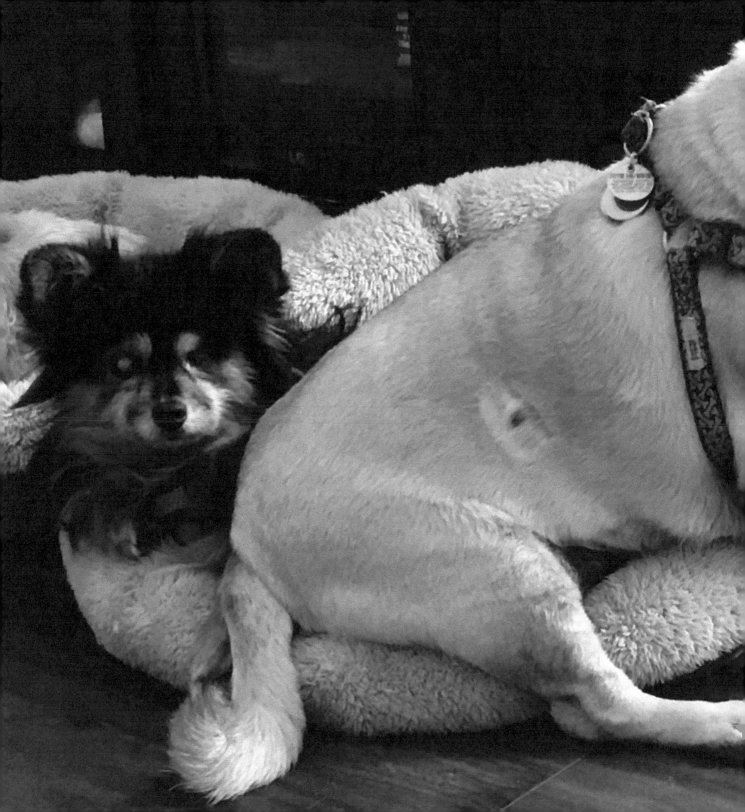

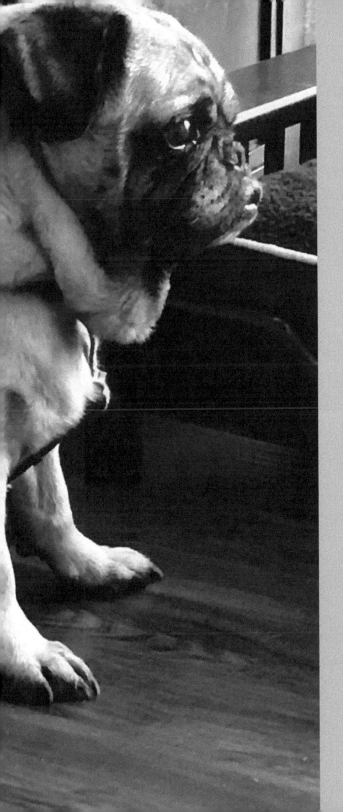

Pugsley and Hannah Bear

When it seems like the world is crashing down upon you, a slight adjustment can make you realize it's actually quite soft and comfy.

75

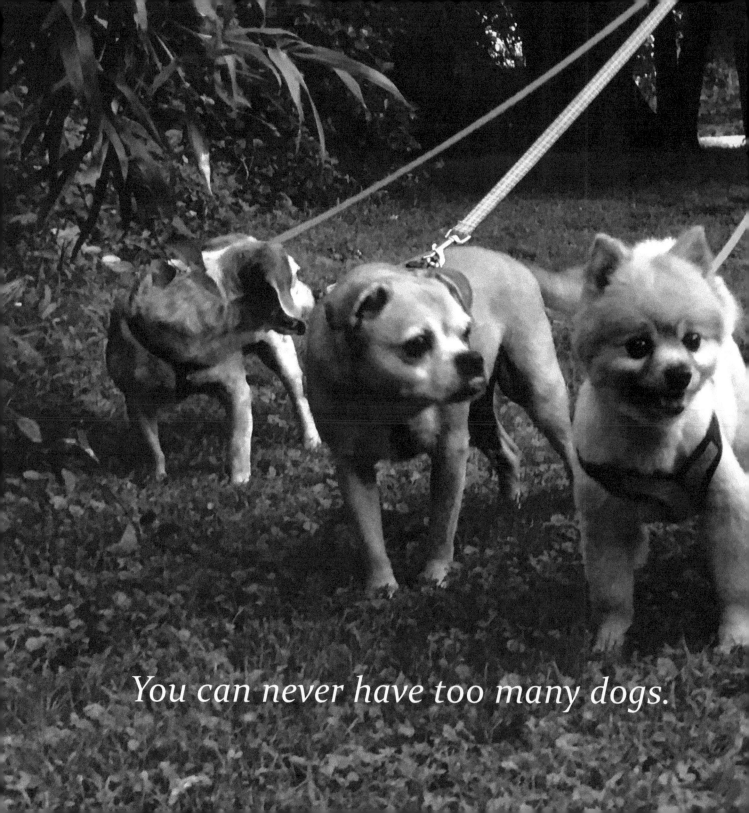

You can never have too many dogs.

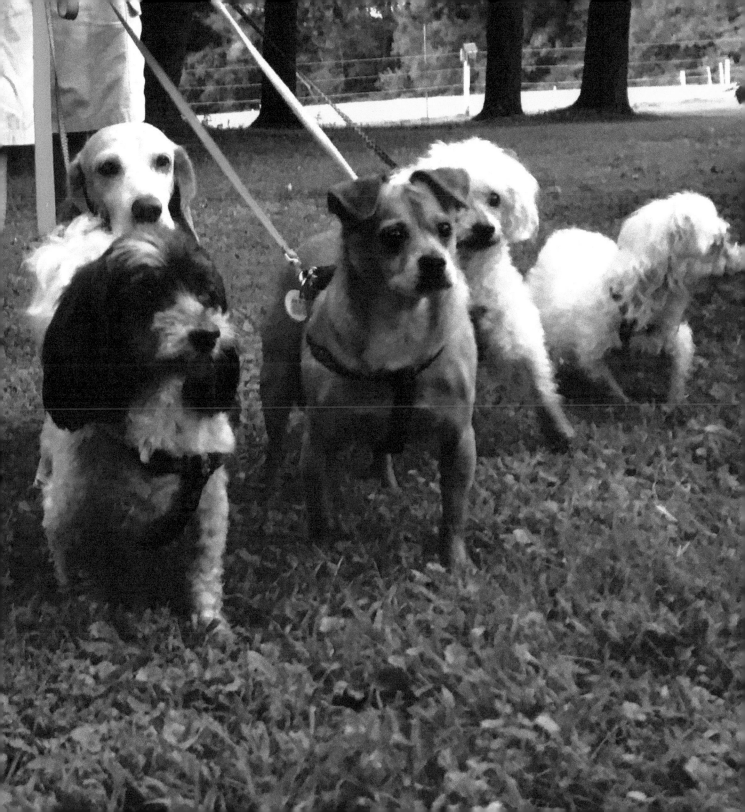

Sunshine

*Until one has loved an animal,
a part of one's soul remains
unawakened.*

–Anatole France

78

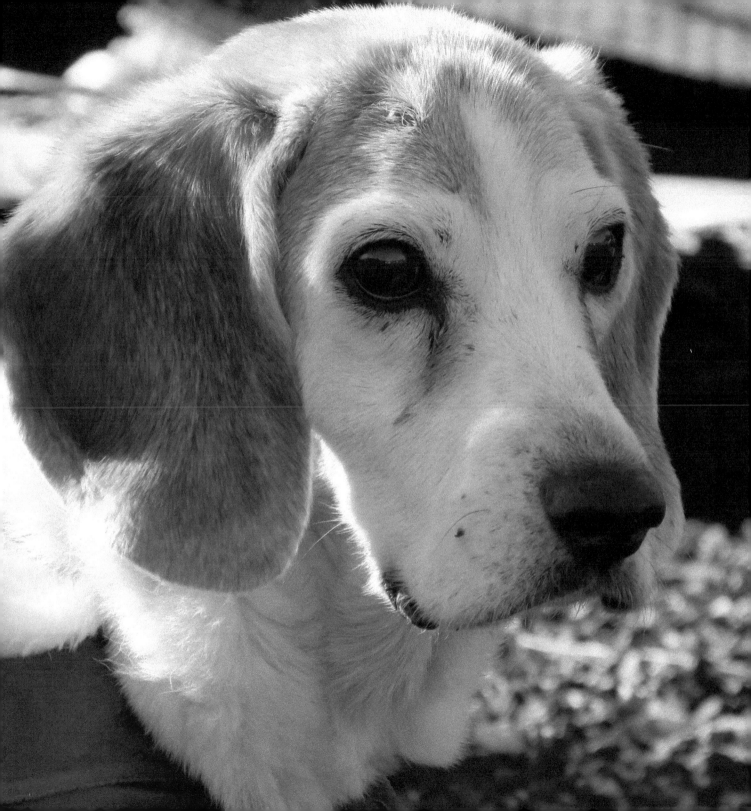

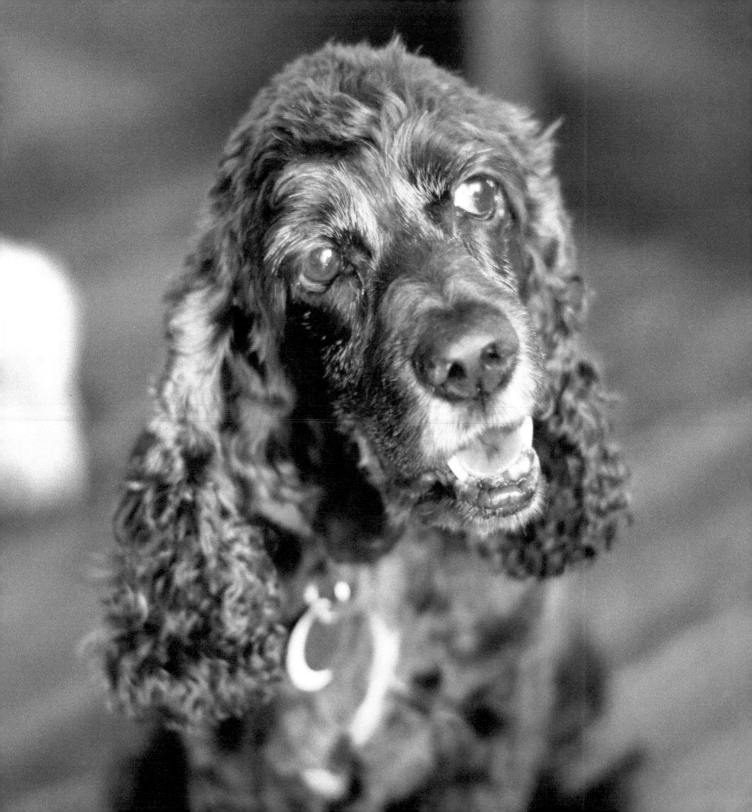

Hooch

Happiness is like a playful dog; the more you chase it the more it will elude you. But if you turn your attention to other things, it will come and sit softly with you.

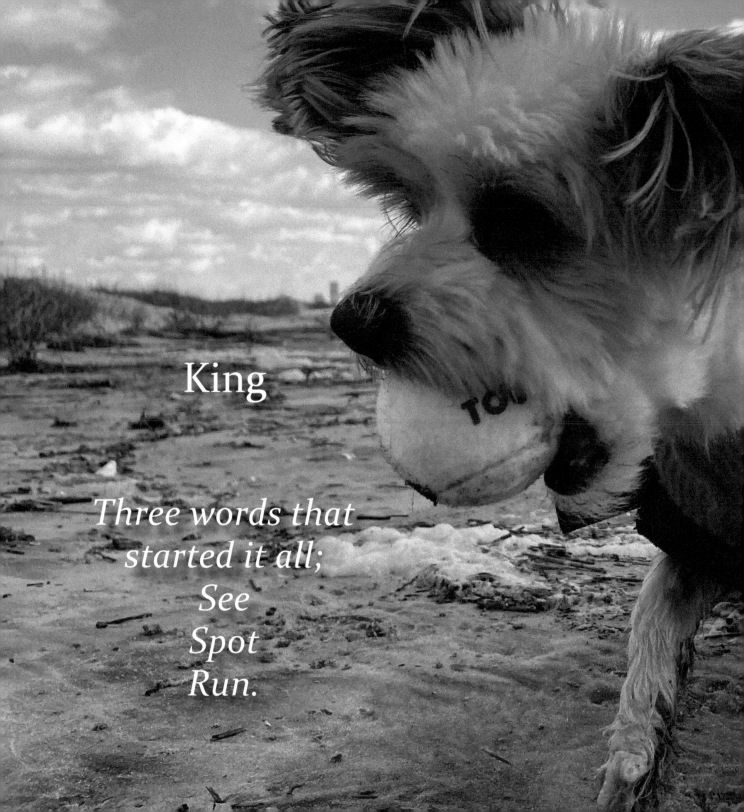

King

Three words that
started it all;
See
Spot
Run.

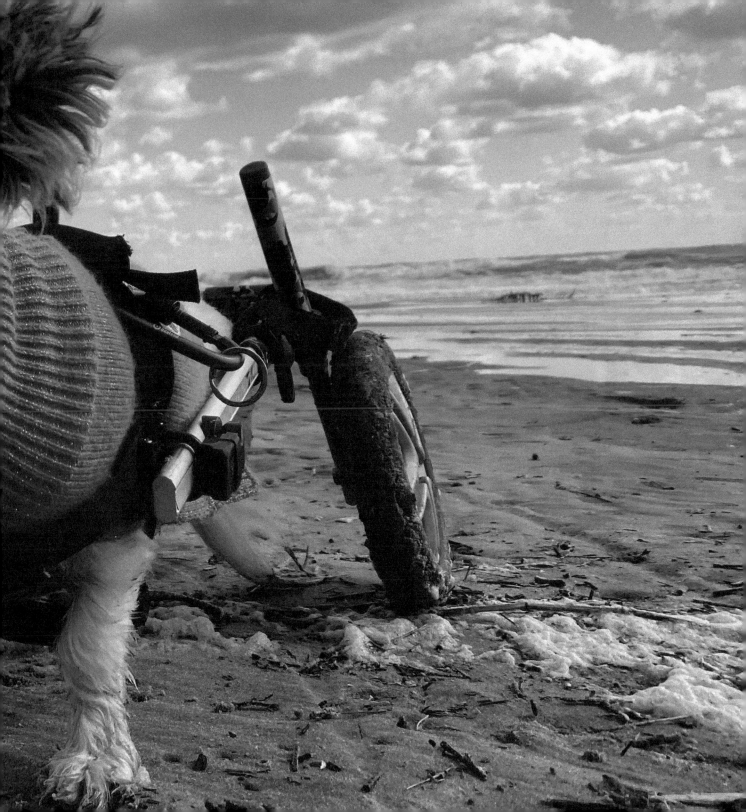

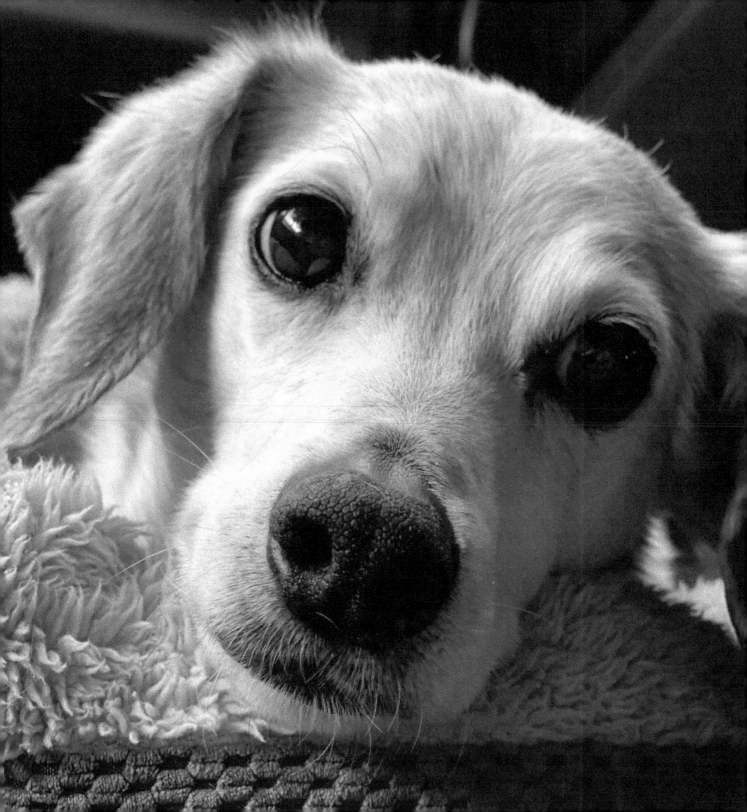

Randy

A dog is the only thing on earth that loves you more than he loves himself.

–Josh Billings

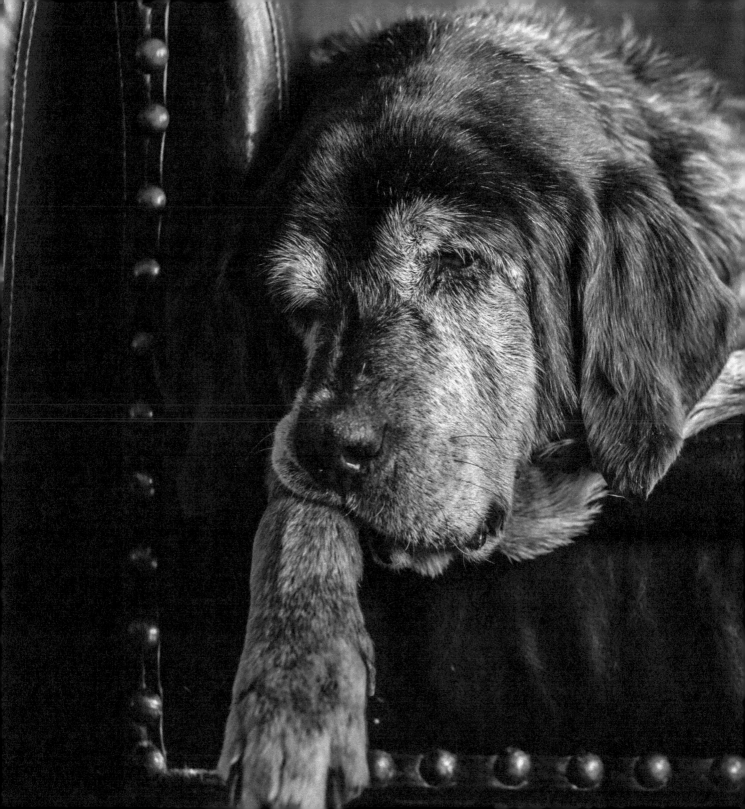

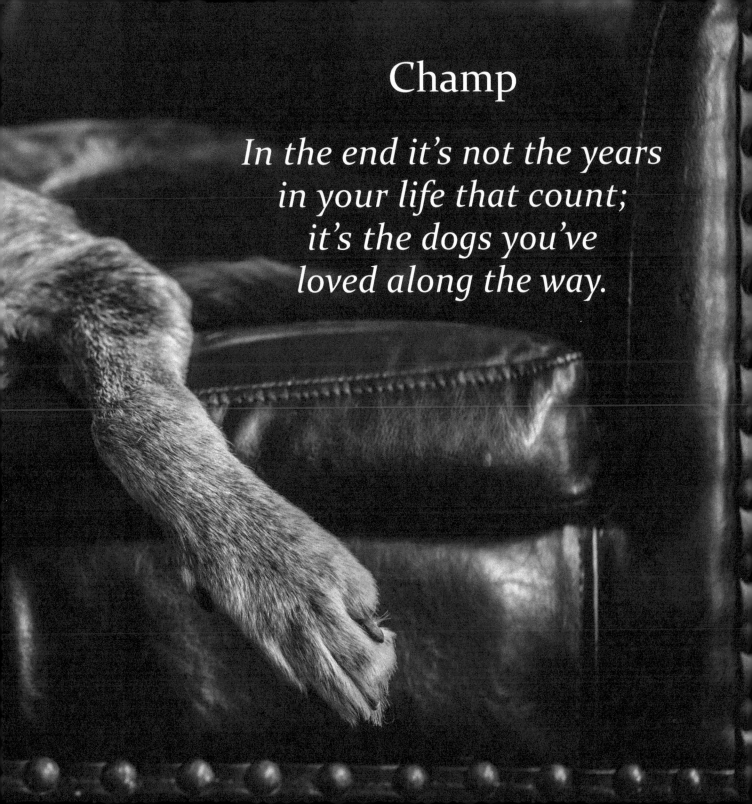

Champ

*In the end it's not the years
in your life that count;
it's the dogs you've
loved along the way.*

MLBob

"Is this Heaven?" he asked.
"No" I replied,
"it's Monkey's House."

88

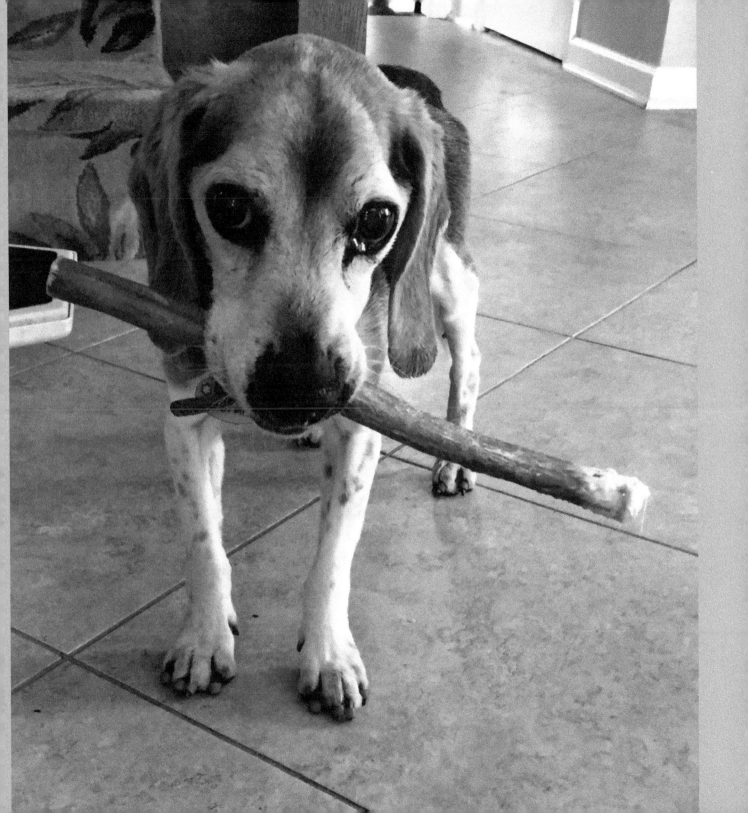

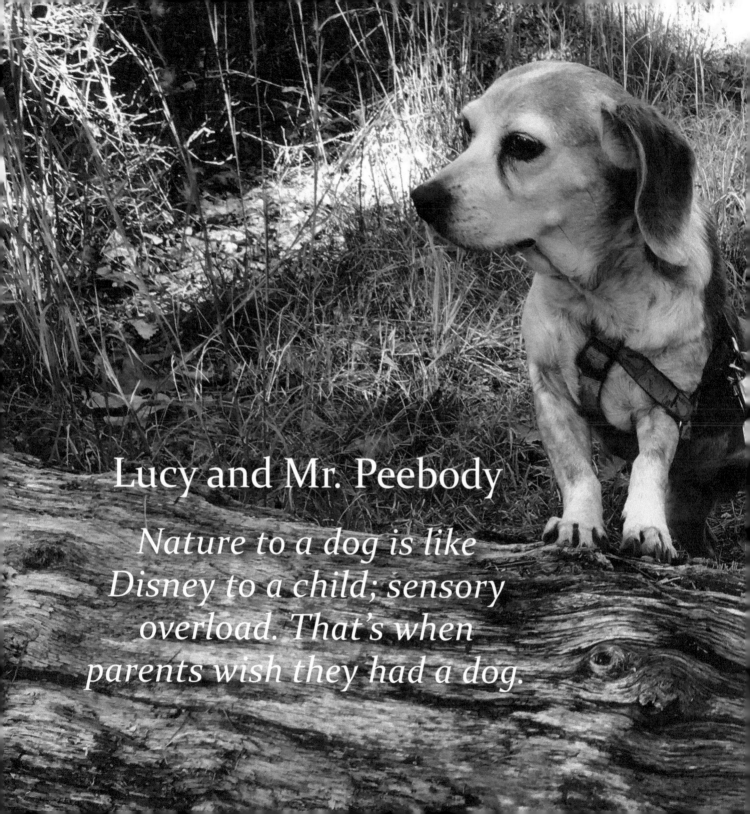

Lucy and Mr. Peebody

Nature to a dog is like Disney to a child; sensory overload. That's when parents wish they had a dog.

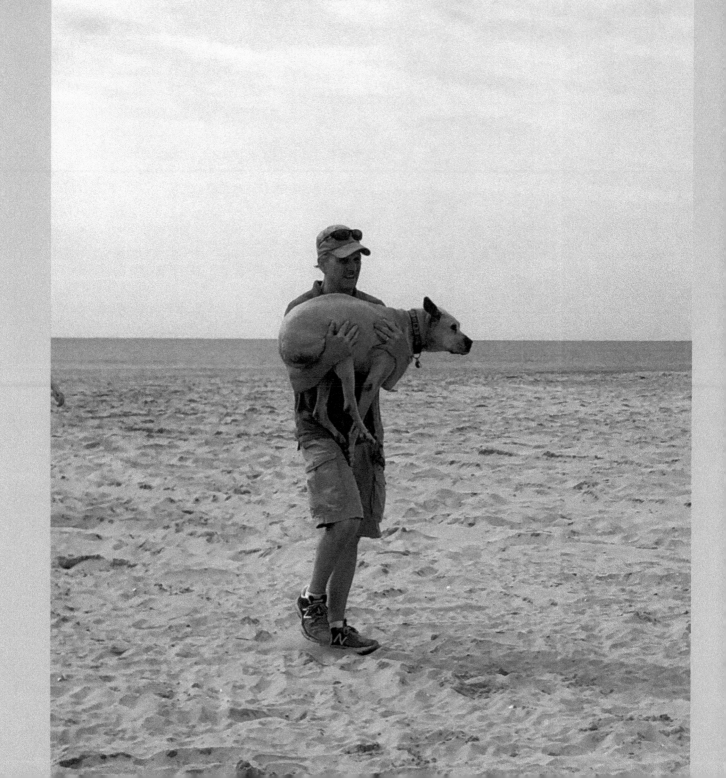

LA and Jeff

She ain't heavy, she's my dog.

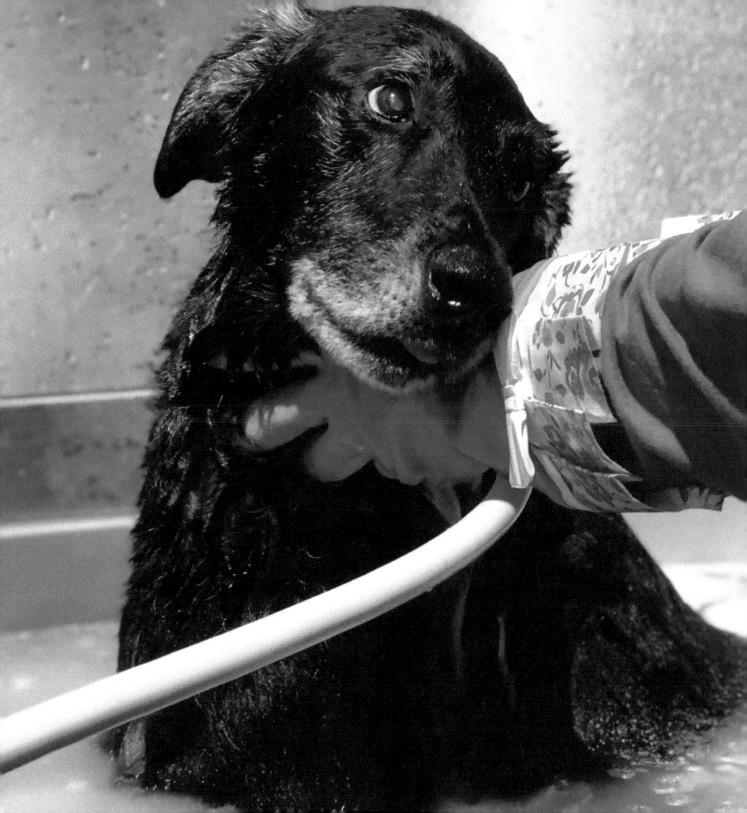

Cole

*Love is when you
look into someone's eyes
and see everything you need.*

95

Pugsley and Belinda

*Don't let challenges
stop your dreams.
There's always a way.*

Melvin

My little old dog...
a heartbeat at my feet.

–Edith Wharton

 98

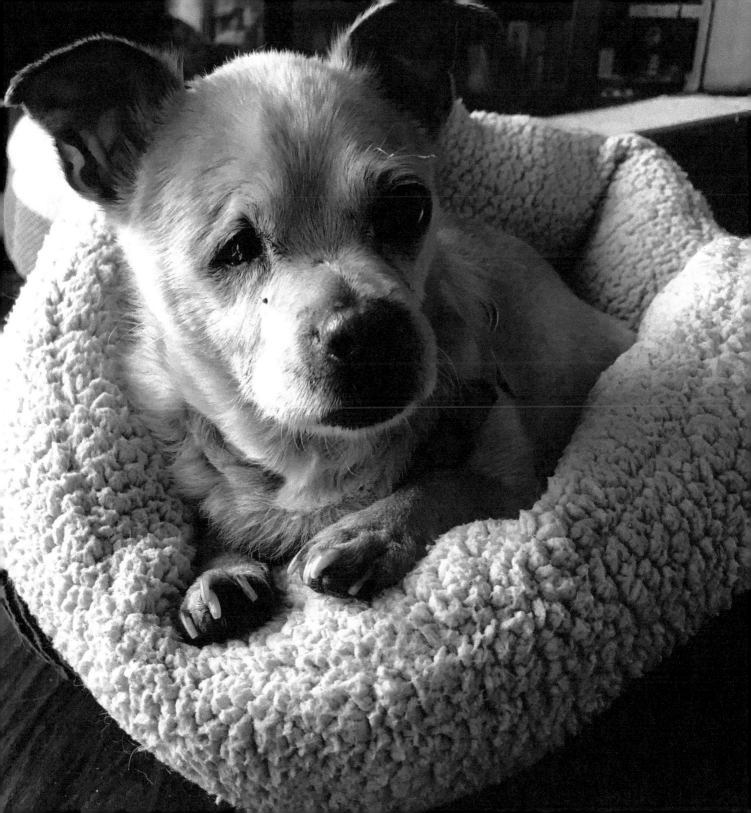

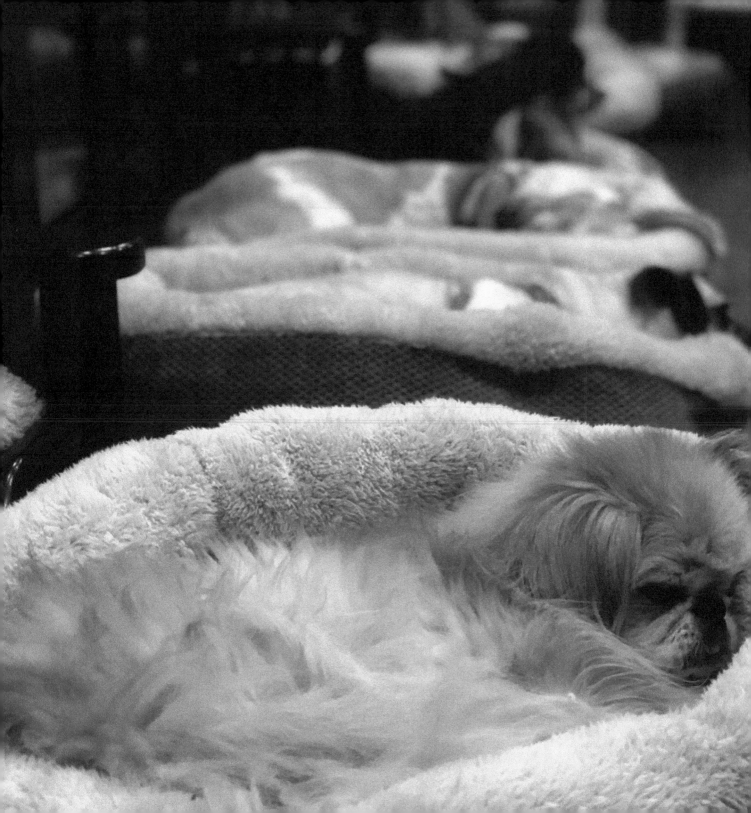

Princess Granny and friends

Snoring from a person is deafening, yet snoring from your dog sounds like a well-played symphony.

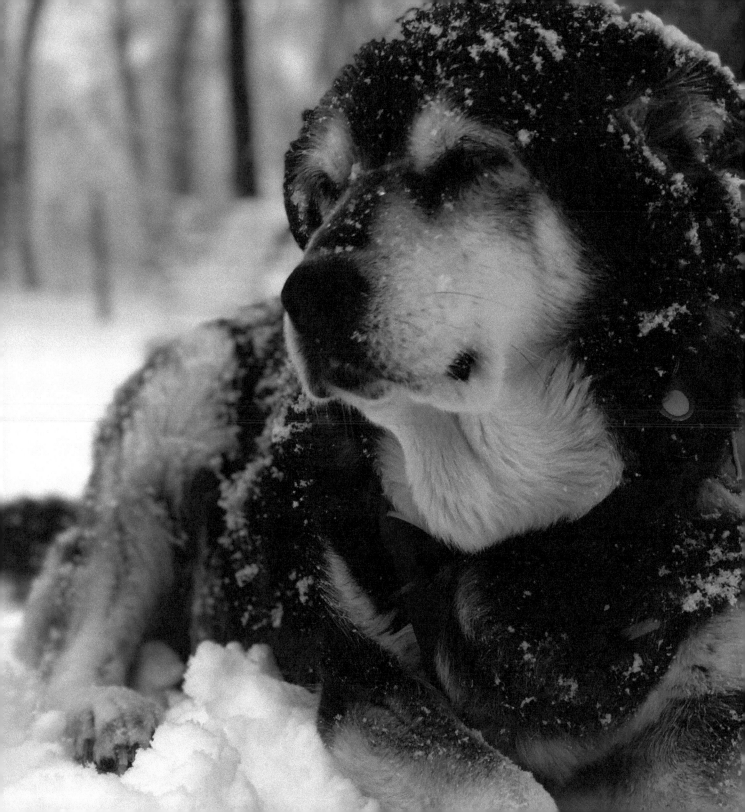

Harley

A dog is like a snowflake,
each unique in their
own beautiful way.

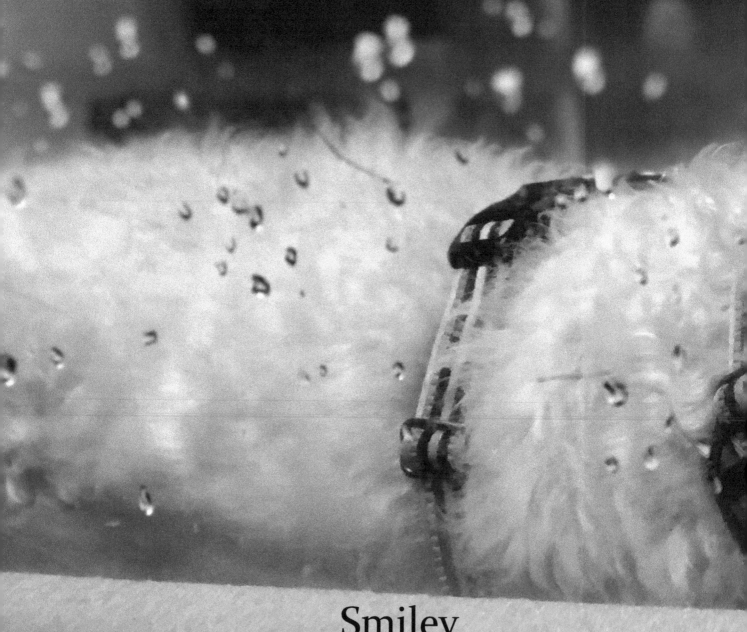

Smiley

When we finally realize we do have weaknesses and are willing to work on them,

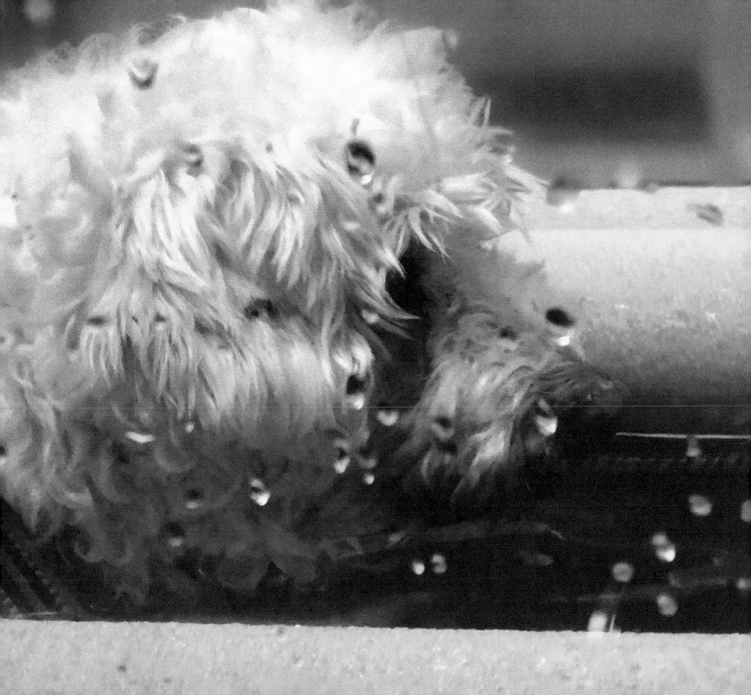

... that's when we find our true strength.

Violet

The comfort of a stuffed animal is timeless.

FiFi

You only live once,
but if you've had dogs in your life,
once is enough.

108

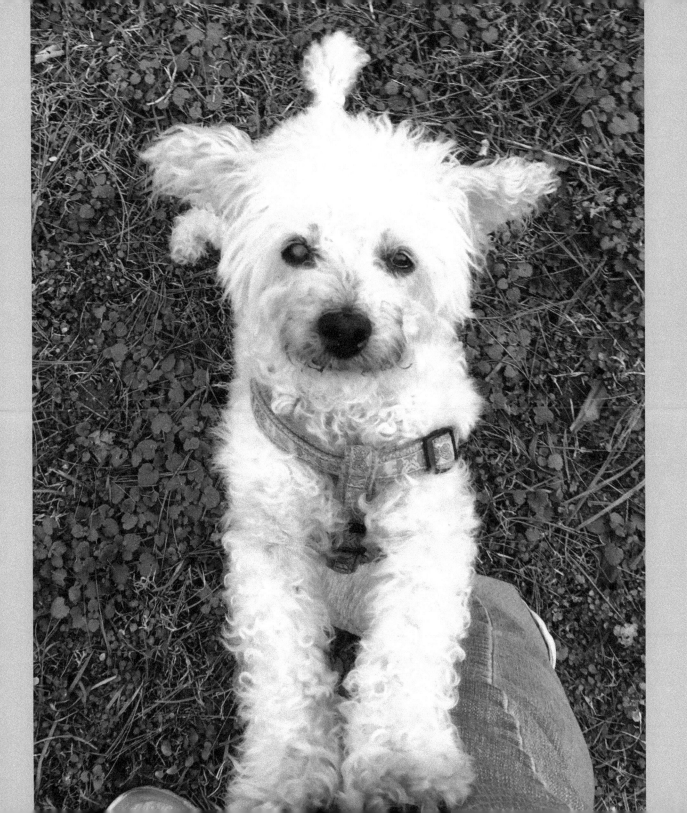

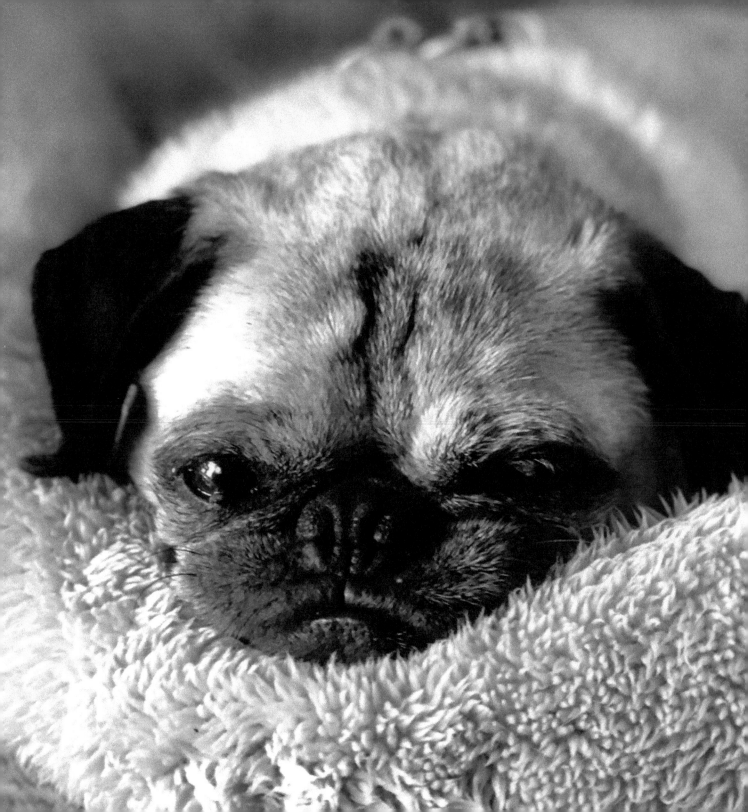

Belinda

They say owners look like their dogs;
my wife brought me home a pug.

Fletcher

*A dog takes their
job very serious—
find stick, chew stick,
find another stick.
If only people were
so committed.*

112

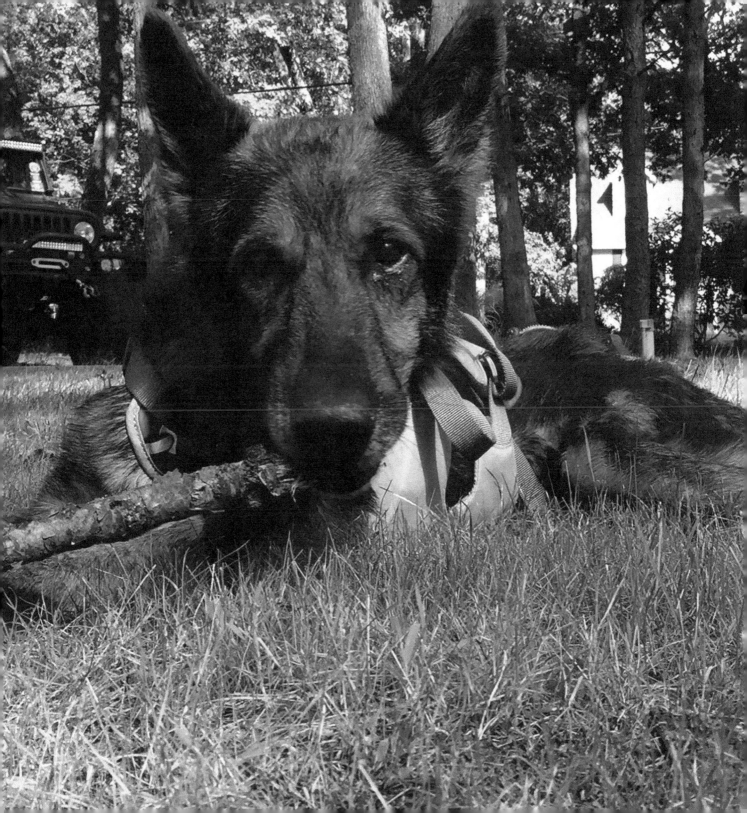

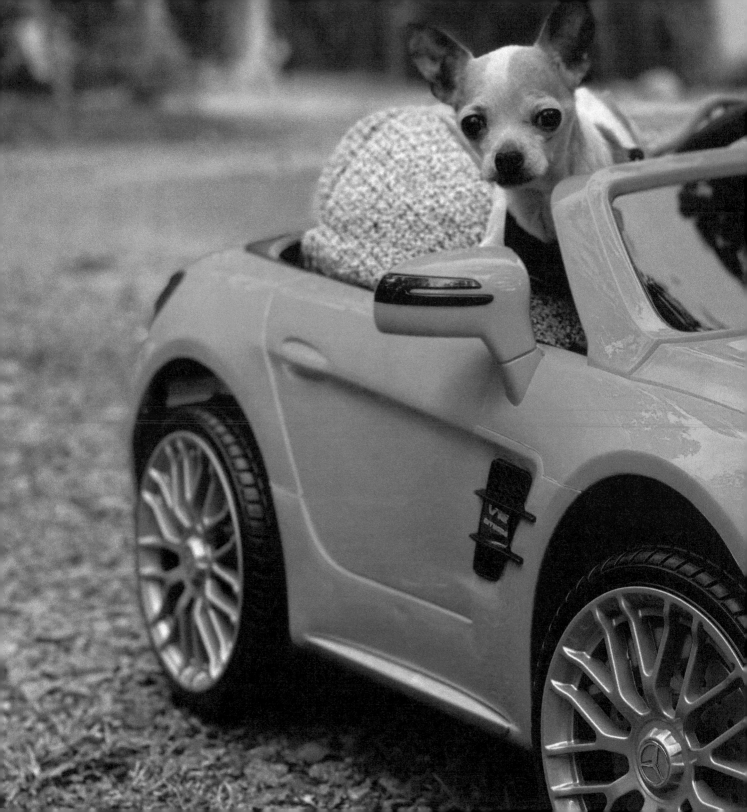

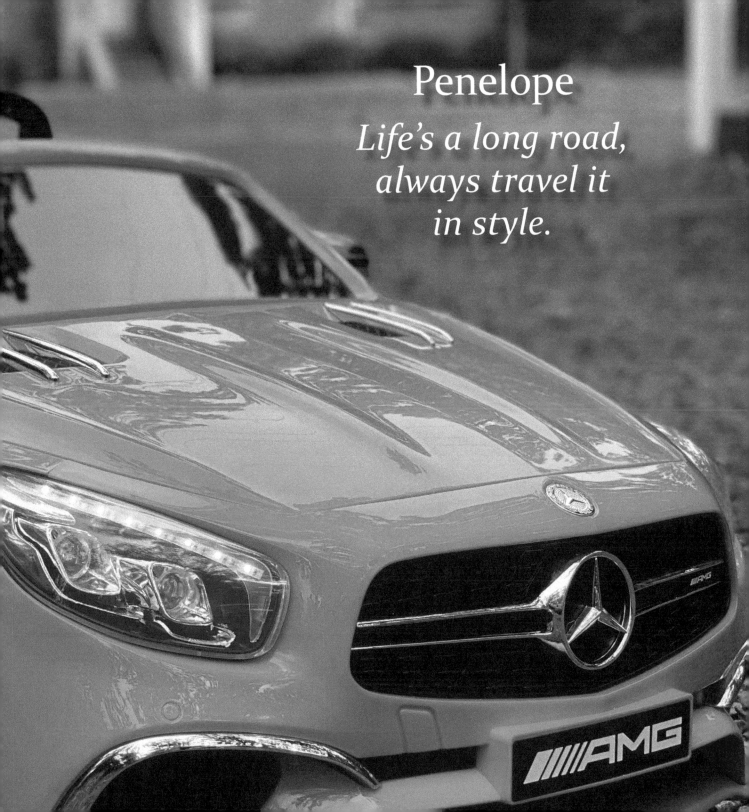

Penelope

*Life's a long road,
always travel it
in style.*

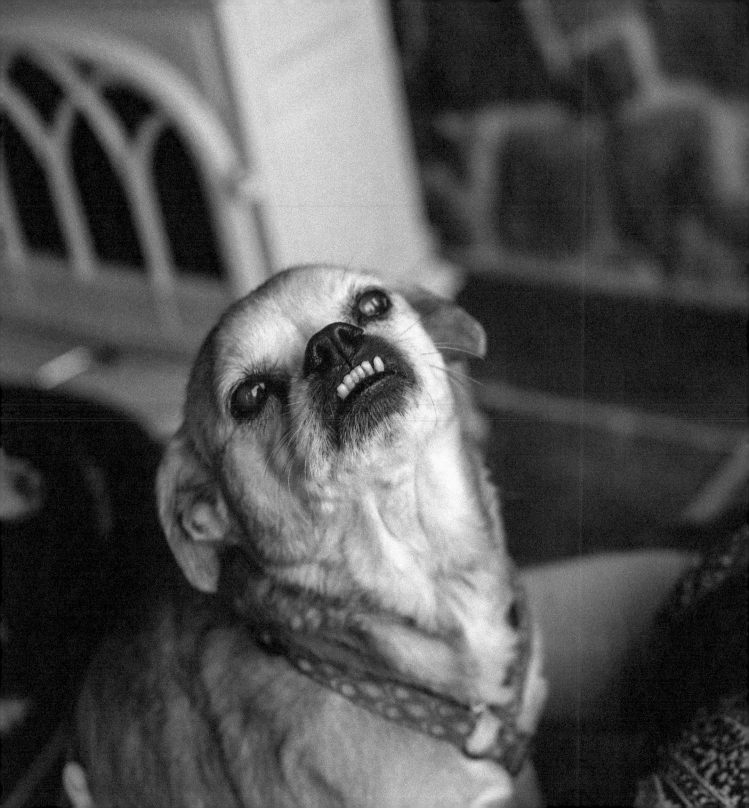

Bunkey

*Use your smile
to change the
world; don't let
the world change
your smile.
–Author Unknown*

Maisey and Darla

Shuffle your feet, lose your seat.

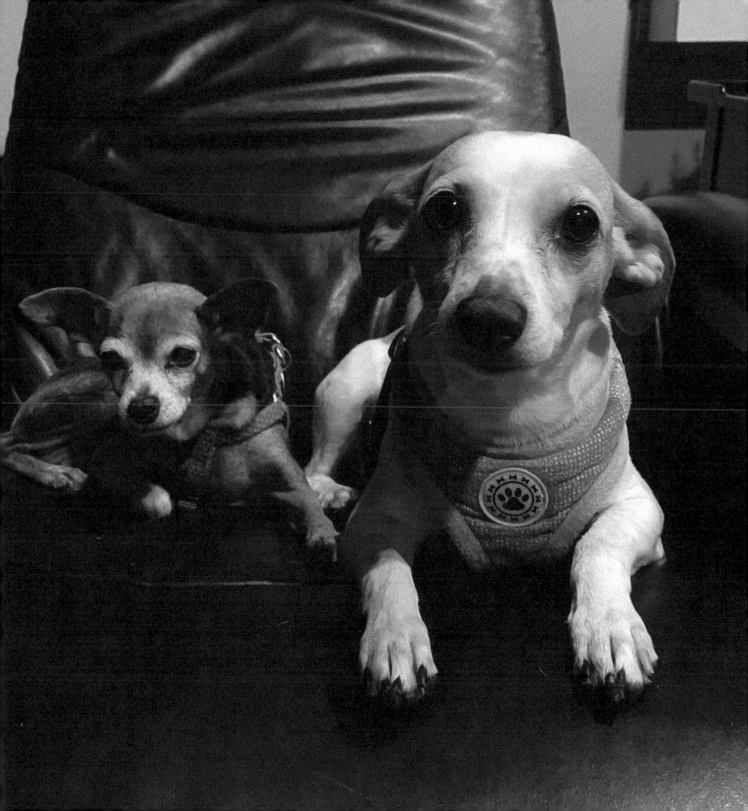

Dozer

*Happiness
is a
spa day.*

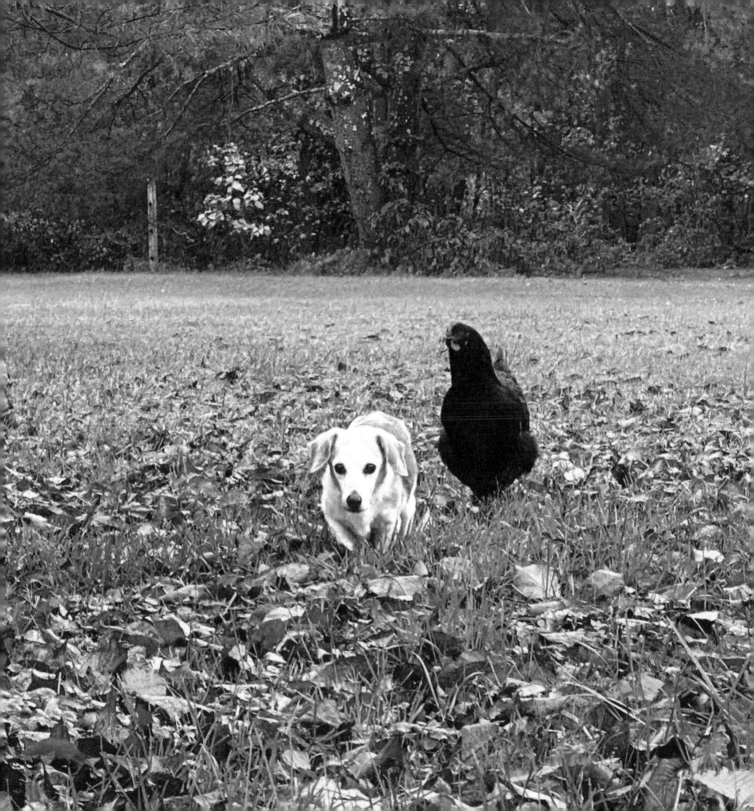

Randy

Friends come in all shapes, sizes, and colors. The only thing that matters is that they have your back.

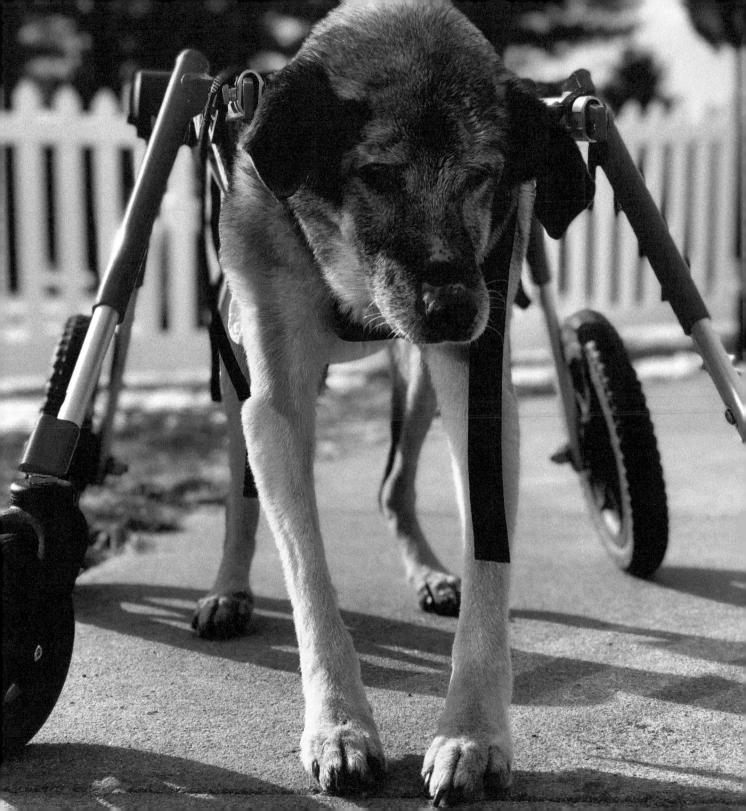

Holly

The cart is not a symbol of disability. It's a vehicle of liberation and freedom—a chariot of independence.

Parker

Falling in love with a dog is the easiest thing in the world, falling out... IMPOSSIBLE.

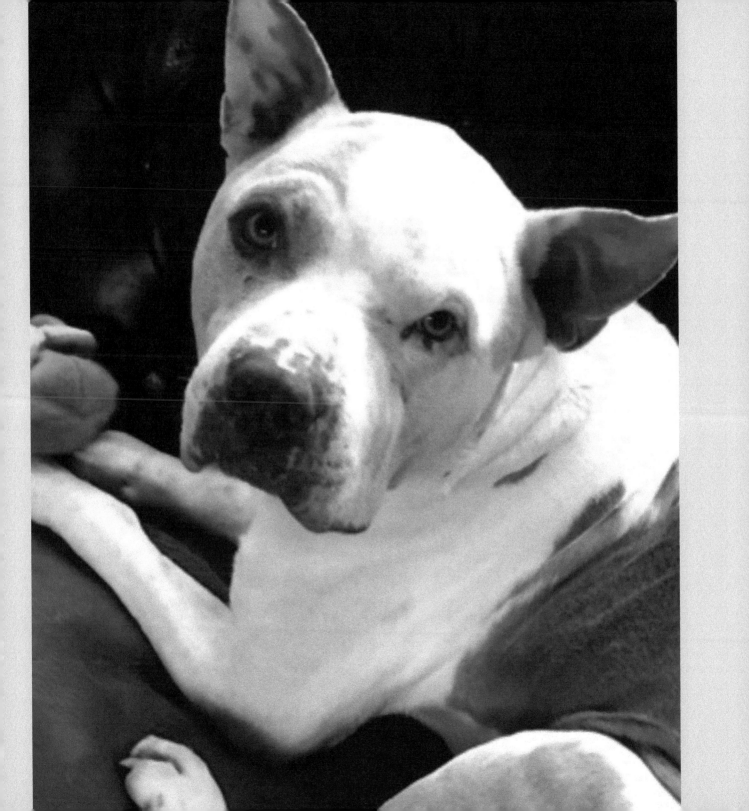

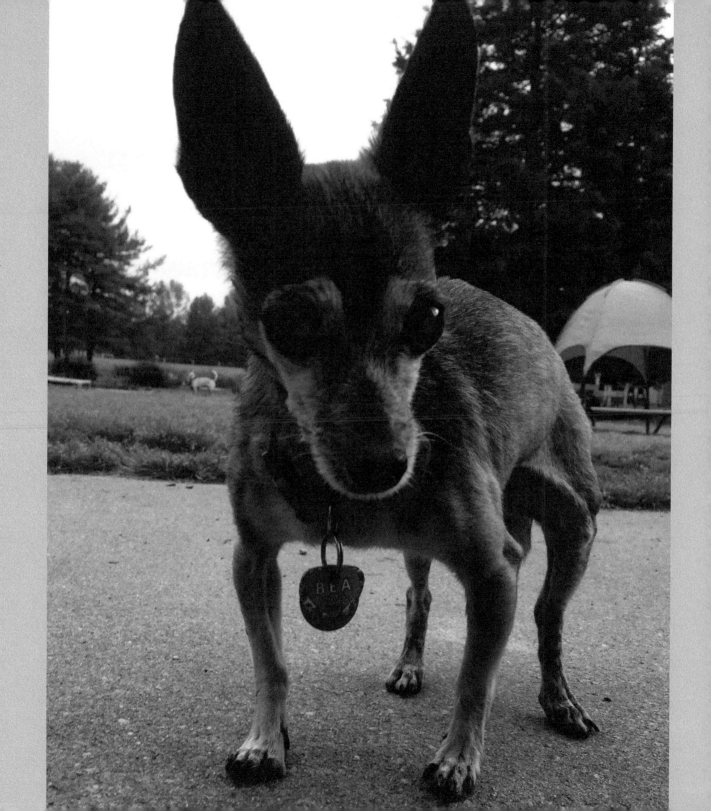

Bea

*You'll learn to keep your
ears perked and listen when
you're advised not to select the
Clydesdale for the all-day trail ride.*

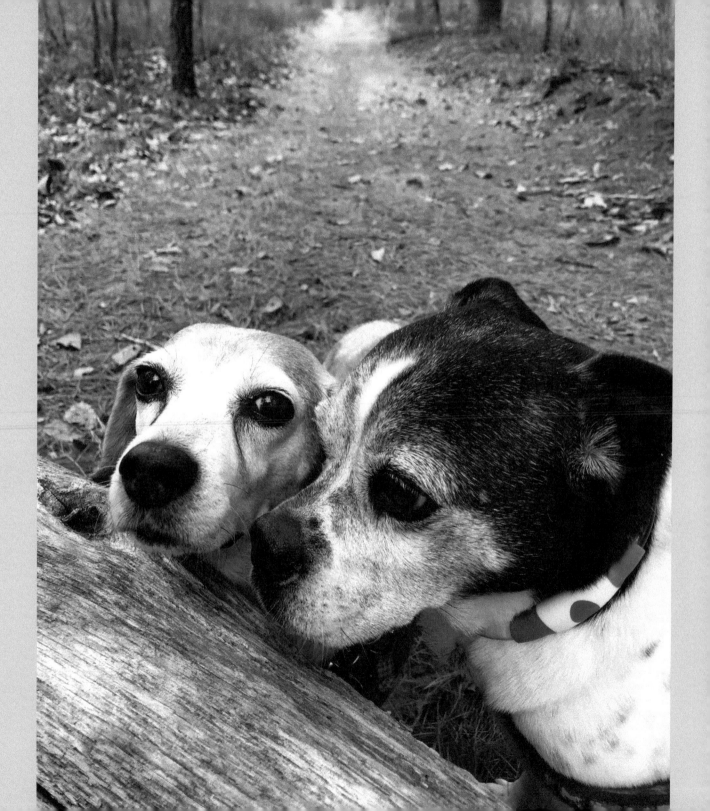

Lucy and Bugsy

The journey may be long,
but with a friend by your side
anything is possible.

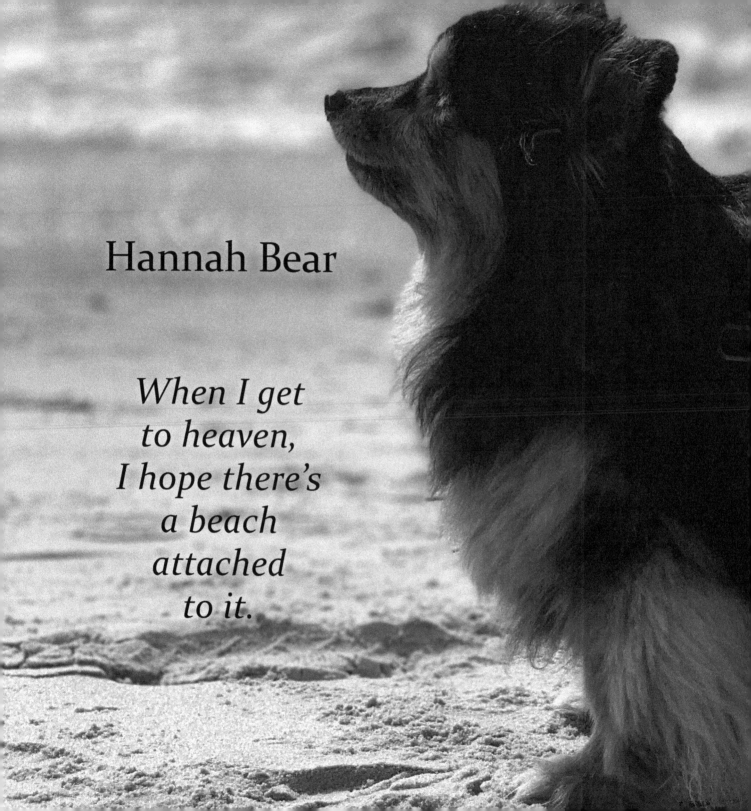

Hannah Bear

*When I get
to heaven,
I hope there's
a beach
attached
to it.*

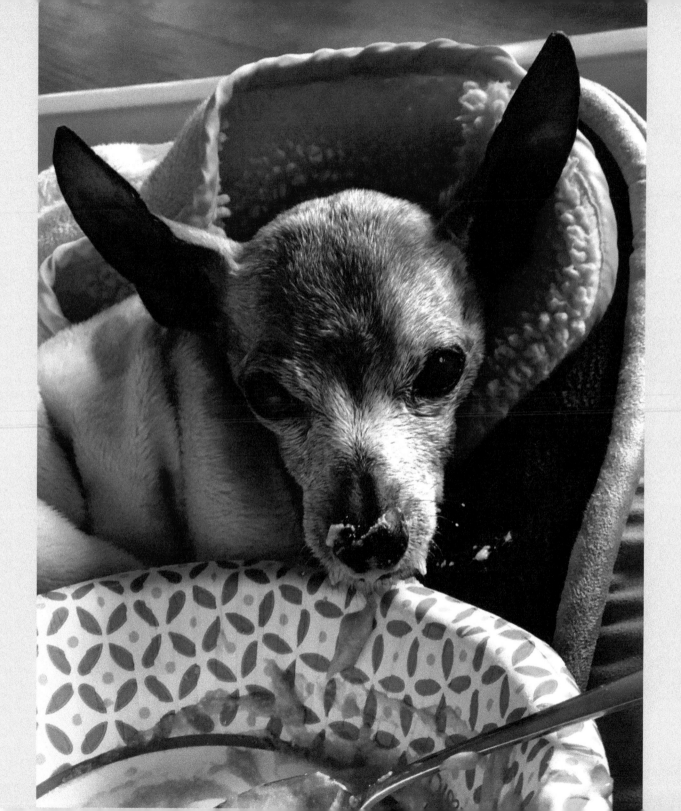

Penny

We are what we eat;
thank goodness it's not
how we eat.

Maggie

A beautiful face will age and a strong body weaken, but a dog's loving soul never changes.

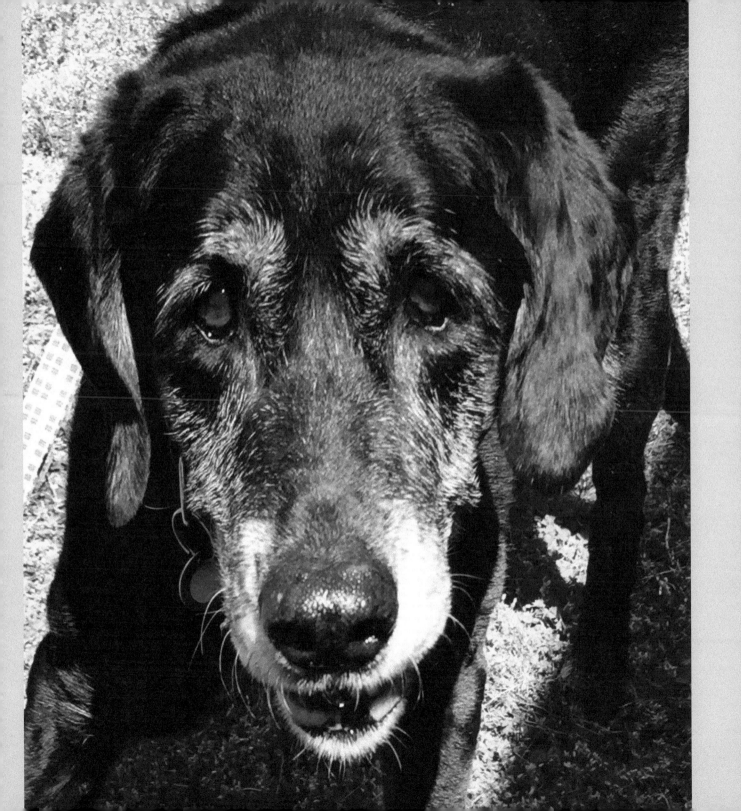

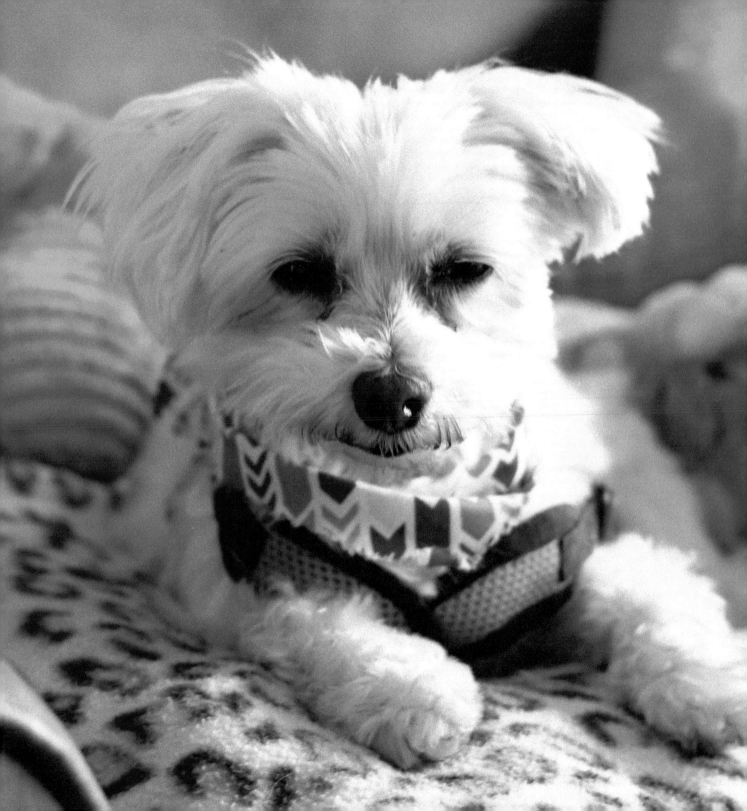

Kirby

Days when you just can't keep your eyes open are the days you claim you practice meditation.

Bottons

Sometimes you need to lose your past to be right where you're supposed to be.

Grandpaw and Flick

*Don't take yourself too seriously.
Sometimes you just need
to do the Hokey Pokey.*

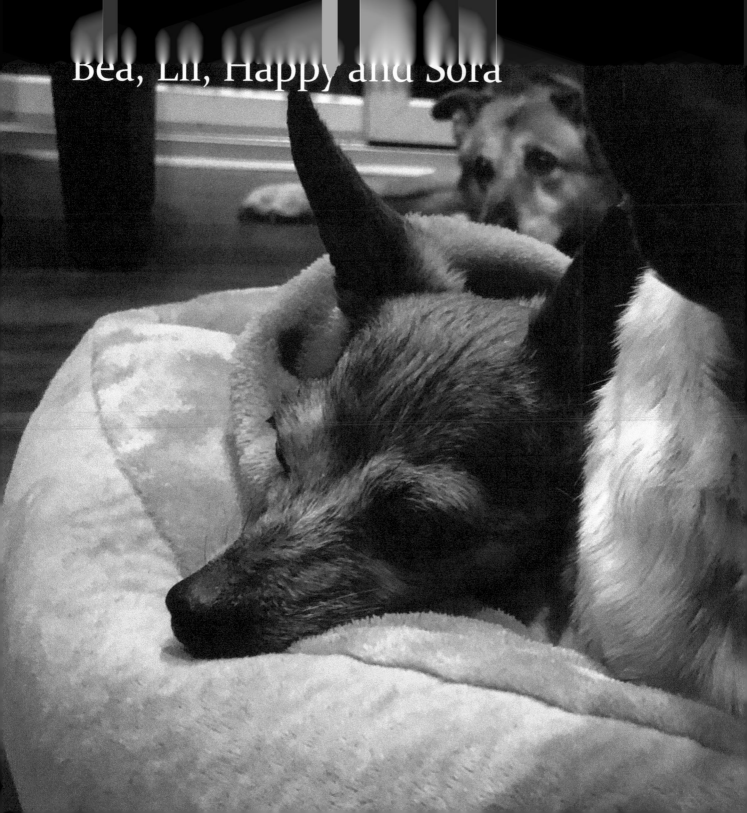
Bea, Lil, Happy and Sora

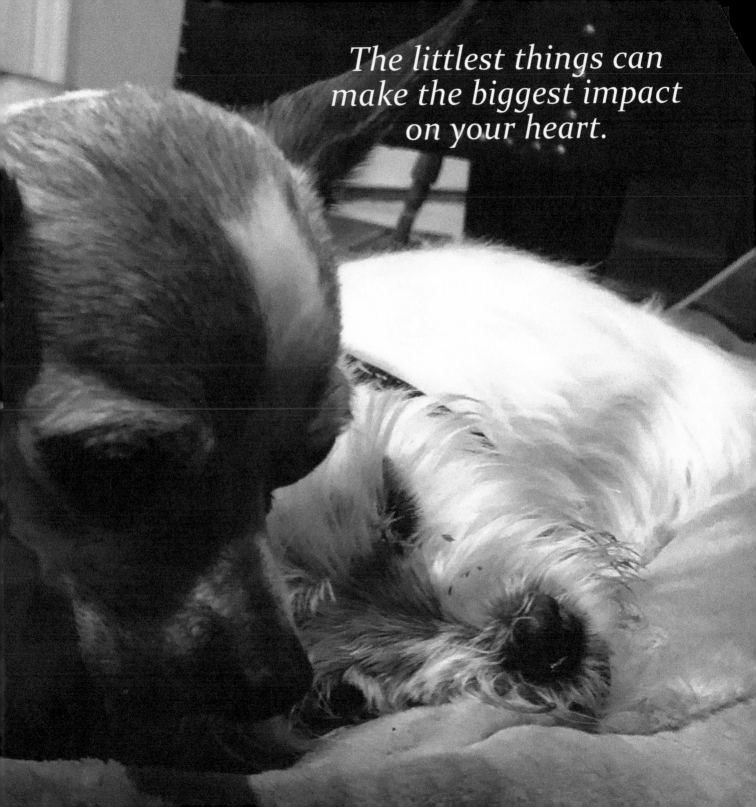

The littlest things can make the biggest impact on your heart.

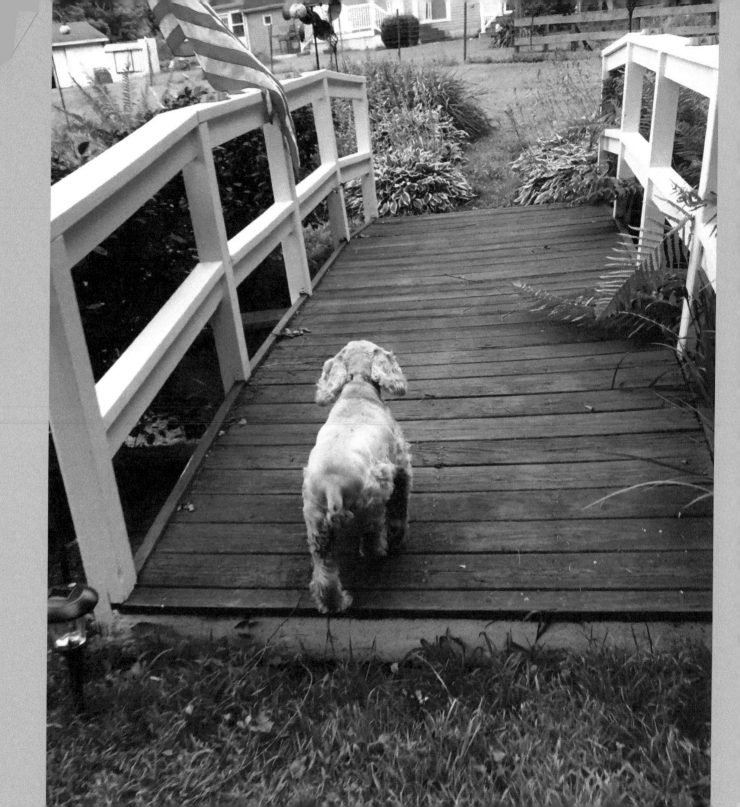

Molly

*The final stretch
on the way home
always feels
so comforting.*

Thanks For Reading
Life's a Dog Bone
Chew it All Day Long!

Now is the time to take action.

- If you enjoyed this book, please consider leaving an honest review on the book's product page on Amazon or the online bookstore where you purchased it.

- Recommend this book to your dog-loving friends and family. Give a big shout-out on your social media platform.

- To find out more about Monkey's House a Dog Hospice & Sanctuary visit monkeyshouse.org.

Get a copy of **Where Dogs Go To Live** to learn more about their non-profit through inspiring and heartwarming stories of hospice dogs that called Monkey's House home.

100% of the proceeds of this book go to Monkey's House

149

Where Dogs Go To Live!

A 5 Star Amazon Bestseller

- "An inspiring and heart-warming book that needs to be read by every dog lover."
 –Rodney Habib, Founder Planet Paws

- "The stories in this book will deeply touch your heart..."
 –Jack Canfield, Coauthor of *Chicken Soup for the Dog Lover's Soul*

- "A must-have book for every dog lover's shelf..."
 –Laura T. Coffey, author of *My Old Dog*

- "Heartwarming, hopeful, funny, uplifting..."
 –David Rosenfelt, author of *Dogtripping* and *Lessons from Tara*

- "Thumbs up... a must read for every dog lover!"
 –Dr. Peter Dobias, DVM, founder and CEO, Dr. Dobias Healing Solutions, Inc.

- "*Where Dogs Go To Live* provides a glimpse into the joy, happiness, and innumerable life lessons learned by living with and loving dogs..."
 –Karen Shaw Becker, Wellness Veterinarian

Available at Amazon, Barnes & Noble, and your local book stores.

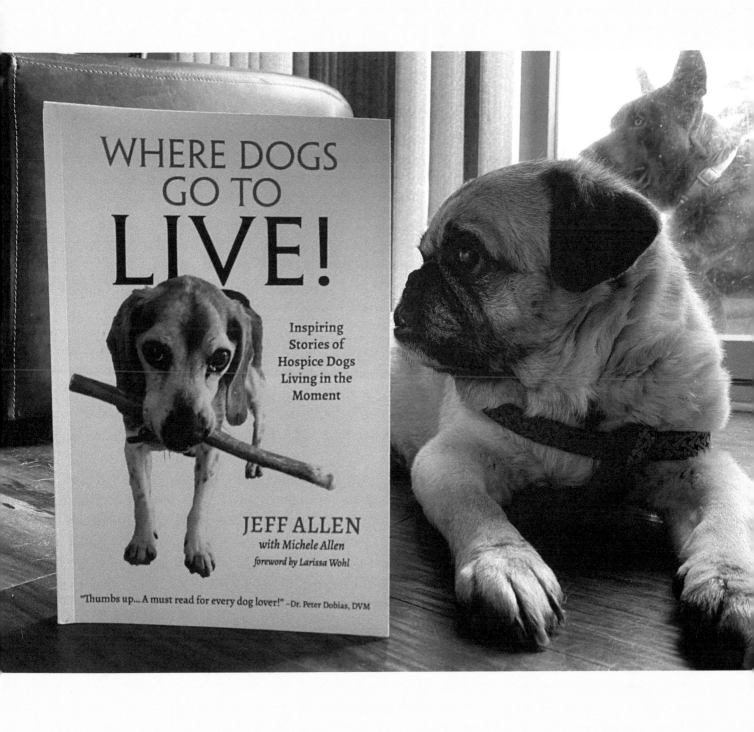

Acknowledgments

This book would not have been possible without the commitment my wife, Michele Allen, made in 2015. The time for talk was over and she started a movement where hospice dogs would no longer be homeless. Their lives mattered and they would want for nothing in their final chapter, Monkey's House a Dog Hospice & Sanctuary was born. Without that initiative this book would have never been, but even sadder, all the dogs in this book would have been euthanized in the back of a shelter.

Christy Collins of Constellation Book Services for tackling which might have been her first coffee table book on dogs. Conveying every dog's personality was not an easy task, however she did it masterfully. Thank you for designing such an amazing cover and beautiful layout.

Kristen Kidd and David Weir of Kristen Kidd Photography for the wonderful cover photos of Pugsley and Ariel. We had such a fun time at the photo shoot with the pups and the outcome is remarkable. Not only the pups look great but my author picture makes me truly look like a bestselling author, thank you.

Thanks to those that I used as a sounding board on many aspects of the book: Patricia Allsebrook, Caitlin Bluem, and Tracey Mauro.

To my Quantum Leap coaches, thank you for helping me make this book possible and showing the world hospice dogs are beautiful: Geoffrey Berwind, Debra Englander, Raia King, Cristina Smith, Laura Harrison and Steve Harrison.

To all the aunts and uncles of Monkey's House, you're a big part of the dog's lives. I'm sure the pictures and quotes will bring back great memories. You'll laugh, maybe shed a few tears, but most of all your hearts will know these pups had an amazing time at Monkey's House, sharing special moments together.

With all my heart and deepest gratitude, I thank our global Monkey's House family that has supported us over the years. You have made all of this possible, giving these dogs a second chance at living. Creating wonderful adventures and providing them with a loving home in their final chapter.

Sponsors

A very special thank you to *Life's a Dog Bone, Chew it All Day Long* sponsors. Your financial support helped make this book possible, allowing us to share our beautiful dogs with the world.

Amy French	Ellen Zachary	Maria Termini-Romano
Amy & Bruce Jester	Geri Smith	Maureen Cohen
Amy Robinson	Gwen O'Loughlin	Nichole Bartlett
Anne Reidy	Henry & Patricia Solms	Pat Allsebrook
Annika Recinos	Holly Jones	Patricia Folmsbee Henderson
Becky Warren	Jerri & Jim Golis	Patricia Galbraith
Blake Crane	Joyce Rath	Paul Benjou
C.A. Raymond	Julia Speicher	Richard Baker
Carol Joline	Julie Miller	Robert Cummings
Charles Culbertson	Justine Flory	Rosemary Rosencrans
Christina Denney	Kaiden Jones	Sandi Wright
Christine Delahunty	Kathryn Polley	Sandra Dill
Cindy Trueson	Kathy & Steve Biedenbach	Sara Wozniak
Claire Tindall	Kelly Christensen	Sharon Anderson Torres Colon
David Sole & Family	Kelly Munkwitz	Stacey Herrick
Dawn Ritzie	Lana Heather	Susan Sherbine
Deanna Murdy	Leo Madsen-Vallee	Terry Flannery
Denise Diiulio	Lynn Urrutia	Tracey Mauro
Dennis Bordan	Maggie Rovner	Vincent & Michele Sorrentino
Desiree Simon	Maria Restrepo Forte	Trish Brown

153

About The Author

JEFF ALLEN is the cofounder of Monkey's House a Dog Hospice & Sanctuary and the bestselling author of ***Where Dogs Go To Live!: Inspiring Stories of Hospice Dogs Living in the Moment***. He leads a dual life helping people and dogs alike as a manager in Human Resources at a pharmaceutical company and by running Monkey's House (monkeyshouse.org) with his wife, Michele Allen. Their sanctuary has been recognized for its outstanding work saving and caring for hospice dogs, they have received many awards including Rescue of the Year in 2017 by World Dog Expo. Living a life among twenty-five hospice dogs has given Jeff a different outlook on life, seeing the beauty in all dogs and experiencing the unconditional love only a dog can give. He and Michele live in Southern New Jersey with their pack of furry kids.

"The mission of Monkey's House is to provide loving care to homeless dogs with terminal diagnoses or hard-to-adopt disabilities. We strive to promote optimum wellness through individually tailored nutrition and exercise in a home setting. All the veterinary care needed for quality of life lived in this peaceful, rural community is provided. Monkey's House is a 501(c)3 nonprofit organization."

CPSIA information can be obtained
at www.ICGtesting.com
Printed in the USA
LVHW071813060821
694730LV00008B/827